BARROW-IN-FURNESS

IN 50

BUILDINGS

GILL JEPSON

AMBERLEY

This book is dedicated to my husband and children, who have supported me.

First published 2018

Amberley Publishing, The Hill, Stroud
Gloucestershire gl5 4EP

www.amberley-books.com

Copyright © Gill Jepson, 2018

The right of Gill Jepson to be identified as the Author of this work has been asserted in accordance
with the Copyrights, Designs and Patents Act 1988.

Map contains Ordnance Survey data © Crown copyright and database right [2018]

British Library Cataloguing in Publication Data.
A catalogue record for this book is available from the British Library.

ISBN 978 1 4456 8097 2 (print)
ISBN 978 1 4456 8098 9 (ebook)

Origination by Amberley Publishing.
Printed in Great Britain.

Contents

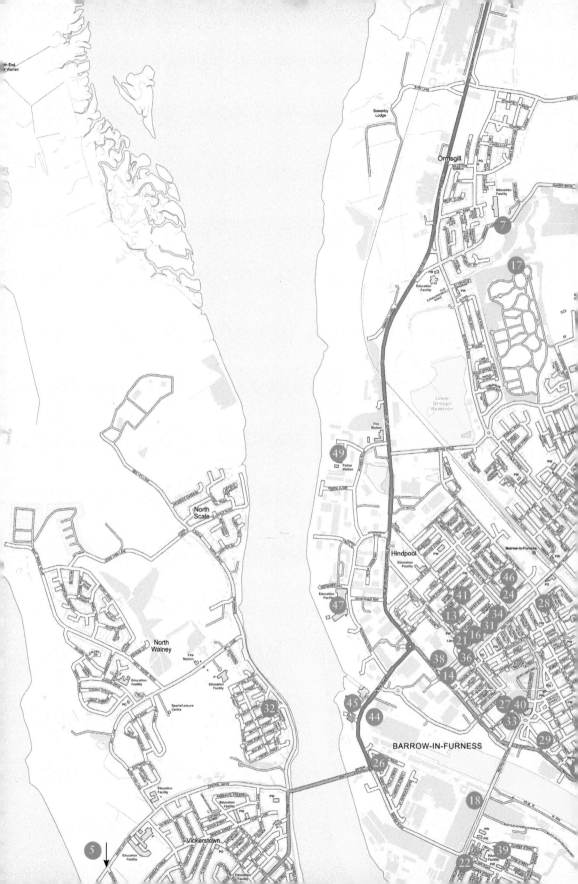

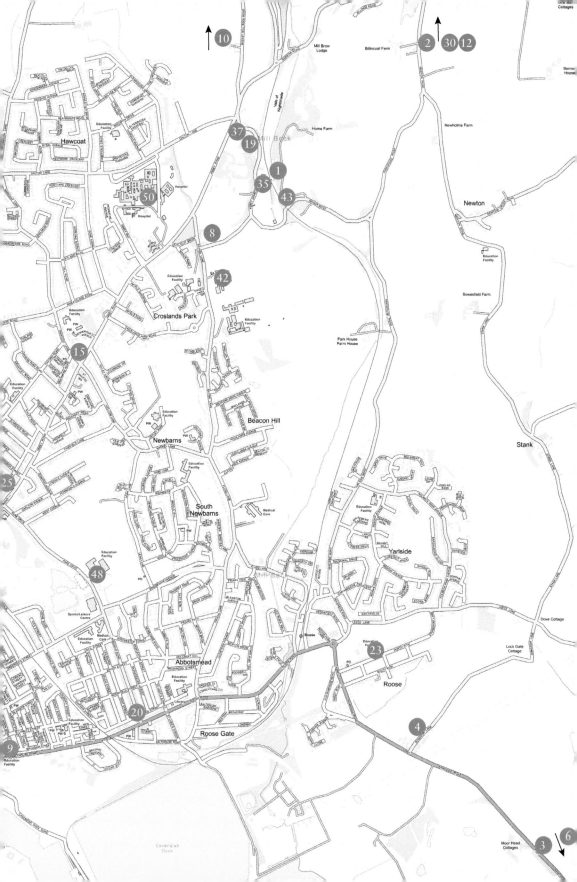

Key

1. Furness Abbey, 1127
2. Dalton Castle, Dalton-in-Furness
3. Piel Castle, Pile of Fouldray
4. Roosecote Farm, Dungeon Lane
5. Queen's Arms, Biggar Village
6. Rampside Hall, Hall Garth
7. Romney's Cottage, Ormsgill
8. Manor Farm, Manor Road, Barrow
9. St George's School
10. Millwood
11. St George's Church, Barrow
12. St Peter's Church, Ireleth-in-Furness
13. St Mary's RC Church, Duke Street
14. The Custom House, Barrow
15. St Paul's Church, Hawcoat Lane
16. Ramsden Hall, Abbey Road
17. Roman Catholic Chapel, Barrow Cemetery
18. Barrow Shipyard (Vickers/BAE Systems), Michaelson Road
19. Furness Abbey Cottage
20. The Washington Hotel, Risedale Road
21. Barrow Public Library
22. Devonshire Buildings, Michaelson Road
23. Roose Primary School, North Row, Roose
24. Cooke's Building, No. 104 Abbey Road
25. Trinity Church, Abbey Road
26. The Crow's Nest, Barrow Island
27. Town Hall
28. Victoria Hall, Rawlinson Street
29. Alfred Barrow Higher Grade School
30. Ashburner House, Dowdales School, Dalton
31. The Technical School (Nan Tait Centre)
32. Vickerstown, Walney Island
33. The Majestic Hotel, Schneider Square
34. Salvation Army Citadel, Abbey Road
35. Custodian's Ticket Office
36. Old Fire Station
37. Abbey House
38. John Whinnerah Institute
39. St John's Church, Barrow Island
40. The Police Station and Magistrates' Court, Market Street
41. College House, Howard Street
42. Barrow Sixth Form College, Rating Lane
43. Furness Abbey Visitor Centre
44. Devonshire Dock Hall, BAE Systems
45. The Dock Museum
46. Emlyn Hughes House, Abbey Road
47. Furness College, Channelside
48. Furness Academy, Parkside
49. The Police Station, St Andrew's Way, Barrow
50. South Lakes Birth Centre

Introduction

Barrow-in-Furness is a mere infant in terms of township. Prior to 1845 it was an insignificant coastal hamlet with little claim to fame. Barrai, as it was first known, was mentioned as a settlement in early history and is recorded as an abbey grange for the abbey of St Mary of Furness. It was always secondary to the 'ancient capital', as Dalton is now termed. Dalton-in-Furness was a small market town with a charter and its own castle housing the judicial centre and gaol administered by the monks. It was on the main road into the area from the east and grew up under the influence of the abbey and had its own parish church. It is mentioned in the Domesday records of 1086 as 'Daltune' and it came under the manor of Hougun, which belonged to Earl Tostig of Northumbria, the brother of Harold Godwineson – King Harold who was defeated by William the Conqueror in 1066. At this time Barrow was too insignificant to gain mention and while we can identify places like Roose (Rhos), Hawcoat (Hietun), Leece (Lies), Gleaston (Glasserton) and Newton (Neutun), all now within the town boundary of Barrow, we have no clear mention of a settlement in Barrow, presumably because it was too small.

This influences how I have approached this book and recorded the buildings that are significant. Barrow is a generic term for a wider area than the existing town. Dalton is still a separate town, but very much within the Barrow boundary and therefore must have mention here too. Barrow only came into its own at the Industrial Revolution. It was used to export slate and iron ore through its small system of jetties and was a natural port waiting to be built. With the advent of the railway this propelled the town into a hive of industry. It soon outgrew its counterpart and the two small towns switched places, Barrow becoming the larger and more prominent. The tiny village that had existed prior to 1845 quickly vanished under a rapid building programme and it dwarfed both Dalton and Ulverston – both long-established market towns.

The Furness Railway was the springboard for the complete industrialisation of the Furness Peninsula. The iron speculators discovered rich seams of hematite in the Roose, Askam, Stank and Lindal areas, and they needed a means of transporting this to processing plants. The railway provided this initially, but far-sighted investors, the Dukes of Devonshire and Buccleuch and railway manager James Ramsden, alongside the likes of Schneider and Hannay, began to amalgamate to form companies to process the ore in the town. Soon there was a rapidly growing industry, including iron foundries, steel mills and associated

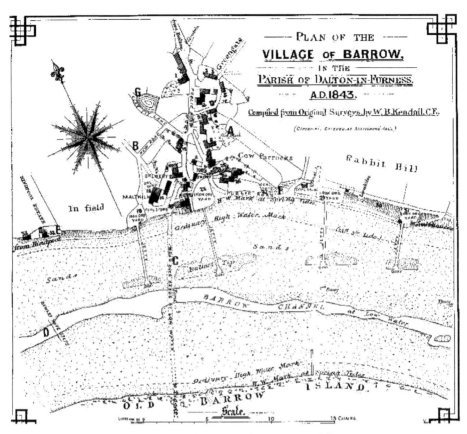

Barrow village based on tithe maps from 1842 by W. B. Kendall.

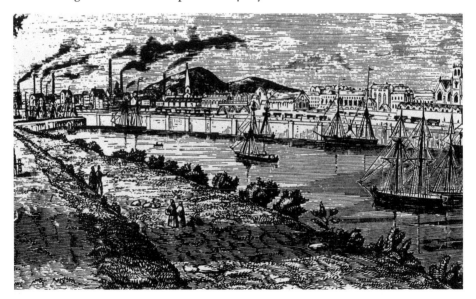

Nineteenth-century engraving of Barrow.

trades centred around the town. This in turn drew in a huge workforce, which necessitated the development of the town and thus the building began. Later, shipbuilding became a massive employer, and it is the one industry that has endured through the centuries.

The confidence and positivity of the town fathers was phenomenal, and this was demonstrated in the investment they made into the infrastructure. The basic housing needs were initially rudimentary and makeshift, but this soon gave way to more permanent provision and the introduction of 'model' housing. The housing was just the start. The town, which had started to grow around the small triangle of the old village and within the farm of William Fisher, was soon replaced by a fully planned modern town, designed on a rectilinear system with wide streets and public buildings. This new building slowly replaced the insanitary and overcrowded accommodation for the incoming workers and the recognisable civic buildings began to emerge. Later in the nineteenth century the town expanded, and it was necessary to provide a municipal cemetery, hospital, churches of all denominations, town hall and a tram system to complement the railway system.

By the end of the century the town was a borough and had a new dock system, which it had been hoped would rival Liverpool. This never quite happened as the emphasis changed to shipbuilding and heavy engineering, but the change in direction involved another population rise and more investment – this time from Vickers, who later felt it necessary to build homes for their workers on Walney Island.

Barrow had expanded to a population of nearly 48,000 by 1881, but the flow of immigrant workers was stemmed by then. Numbers grew as the people settled and the birth rate increased. The town was now established and was not totally reliant on a workforce from outside the area. By 1911 the population was almost 64,000. It peaked again during the First World War when it rose to 74,000 with the addition of another wave of immigrant workers. The town had reduced to a steady 61,000 by 1921 and since then has fluctuated according to the level of work available and the number of people arriving in the town to undertake it. It must be said that although people gravitate towards the shipbuilding industry and do raise the population from time to time, this must be offset with the exodus from the town by those seeking other opportunities elsewhere. The current population is somewhere around 65,000 and has declined in the last few years. However, this could change again because the shipyard has gained large contracts recently, which could in turn raise the population once more.

The Victorians showed confidence in their building programme and some of the remaining ones are very impressive and beautiful. The town has quite a unique reputation for listed buildings, with just over 270 listed in the borough. There are eight Grade I-listed buildings, some of which will appear in this book. Although places like the abbey are now in ruin they are still very much in use and loved, so it would be remiss not to mention these. Furness Abbey was a significant part of the history and development of Barrow, and the medieval beginnings have influenced

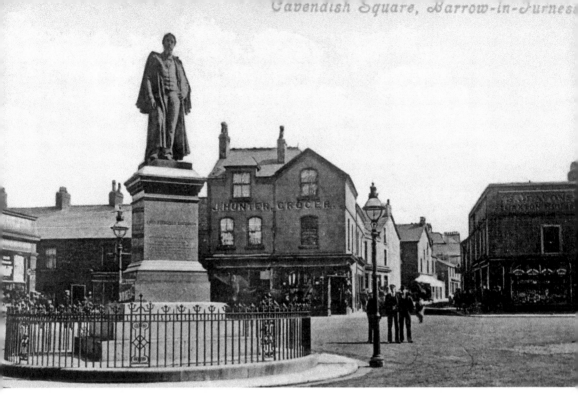

Above: Postcard of Cavendish Square, later replaced by town hall plaza.

Below: The first Furness railway station, later the Railwayman's Club.

the later development and blueprint of the town. The industries that allowed Barrow to grow were recorded in their embryonic form in medieval times. The farmsteads we see now are remnants of the abbey granges and the topography and environment was all developed by the monks and their administration of the land.

Additionally, fifteen Grade II*-listed buildings exist and 251 Grade II-listed building are spread across the town. It is very difficult to isolate the best or most important fifty as this will always be a matter of personal choice in some instances, and it is hard to include every beautiful or important building because there are so many. However, some could not be omitted because they are iconic, such as the town hall (a beautiful Gothic edifice); Devonshire Buildings, which provided housing for workers but is still impressive and worthy of mention; and then some of the controversial new builds like Emlyn Hughes House or the Devonshire Dock Hall. I can't guarantee you will like them all, but I hope they can all be appreciated in their own right. Additionally, the confines of 'Barrow' means that some of the far-flung places in the borough can't be included.

The wave of demolition and rebuilding after the Second World War destroyed many of the popular and loved buildings to make way for new and modern constructions. Many of the older generation mourn the loss of the Roxy Cinema, a lovely art deco building on an important junction as one enters the town; the Coliseum theatre, now replaced with a garden and car park; the Essoldo Cinema, now an uninspiring office block; and Her Majesty's Theatre. We miss the two 1930s Grammar Schools just as much as the Thorncliffe tower block; we have witnessed regal buildings like the 'House of Lords' engulfed by flames; we see important early structures like the first railway station on St George's Square become dilapidated and at risk; and we see shallow attempts to retain old buildings as shells or frontages, like the John Whinnerah Institute or the arch to the Morrison's site, a remnant of the industrial past. The town has done well to survive as well as it has, but there are swathes of the old town that have been replaced with modern and often more functional designs.

One of these areas is the oldest part of the town – around the market, town hall and Schneider Square. A lot of demolition was undertaken in the 1960s and 1970s to 'improve' and modernise the town. The old Victorian iron and glass market behind the town hall was destroyed in favour of a concrete block built in 1970. The Public Hall was removed too, all replaced with a car park and a small garden to where Sir Frederick Cavendish's statue was moved. The Forum and Market Hall stand on the foundations of Paxton Terrace and Paxton Street, which had numerous small shops and cafés, Cavendish town square with a taxi rank and bus stops. To the right, an empty Furness House office block stands sentinel to the old Schneider Square; this square is interspersed with old and new buildings, a wonderful Victorian doctor's surgery, the Albion public house, the old post office (now defunct and housed beneath Furness House), and leads to Michaelson Road. Here is another office block: Craven House, named after Sir Charles Craven

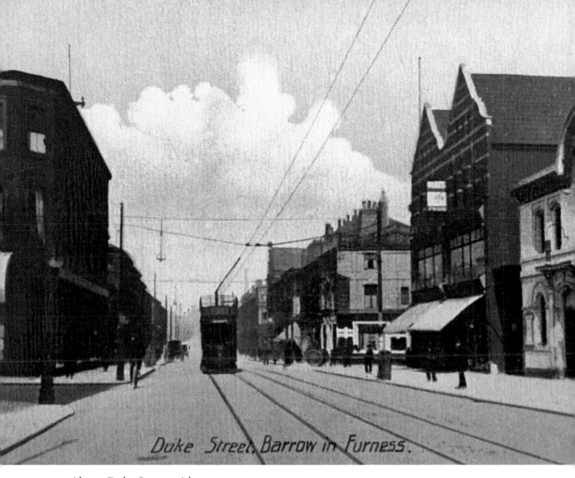

Above: Duke Street, with trams.

Below: Schneider Square and Furness House.

and utilised by Vickers Shipbuilding for many years. More recently, the seven-storey building has been let by Barrow Borough Council to the Department for Work and Pensions, providing space for the Jobcentre and office space for James Fisher & Sons. Refurbishments were carried out in 2003 and 2013 and it is now an established landmark. It is one of the more lucrative assets that the council own.

The Majestic Hotel is a beautiful building and again is lucky to have survived the cull of such buildings, and it fits well with the now redundant Magistrates' Court. One wonders how well it will fit with the new Holiday Inn Express that is planned as the court's replacement. Indeed, the box-shaped new build will dominate this historic area, which partners the town hall across the road. One wonders why there has been no attempt to incorporate the façade of the 1950s court and police station into the design, but one suspects this would take far too much money and ingenuity.

There are some unique and interesting buildings in this book, included because of their story or their quirkiness. These can be appreciated in their own right and hopefully will continue to stand against the ravages of time and the developers. Where old buildings have not only been rescued but enhanced, we can rejoice. The section of Abbey Road opposite Coronation Gardens is a fine example of investment, ingenuity, determination and heritage awareness. The Duke of

Schneider Square Doctor's Surgery.

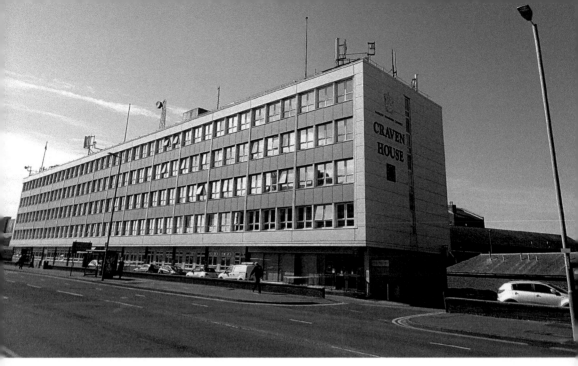

Craven House, Michaelson Road.

Edinburgh, Oxford Buildings and the Cooke's Building is an amazing innovation worthy of praise. It would be wonderful to see the old station and Railway Club saved in this manner; sadly, it is probably too late for the 'House of Lords', which hangs precariously between conservation and destruction at the moment – nobody apparently having the resources or will to do anything about it.

Naturally, no town wants to be completely preserved in aspic and we do have to look to the future as well as the past. It is hard sometimes to embrace the colossal and often featureless buildings of this modern age and externally it is difficult to connect on an emotional level with these. However, we must try. Progress now includes buildings 'constructed' rather than built. These geometric, concrete and metal, composite-cladded structures are functional and streamlined, concerned with energy efficiency, creative space and modern convenience rather than skill, beauty or a hymn to masonry and building. As a historian I naturally lean towards the old, but I can appreciate the more elegant new buildings too. Sometimes it takes time to become accustomed to these contemporary designs, but I do admit to liking Emlyn Hughes House; it took time, but I now appreciate its curves and lines and the nod to the shipbuilding history of the town. Its glistening windows and prow-like shape are elegant and attractive, serving as a perfect foil to the grandiose Victorian buildings on the opposite side.

Maybe one day I will be able to appreciate the tin box structure that is Furness College, which intrudes onto the beauty of Channelside. It is indeed beautiful inside, and as spacious and luxurious as a grand hotel lobby, but it blights its location with its faux-industrial exterior. The new police station, equipped with hot desking and spacious conference rooms no doubt, is probably better placed to

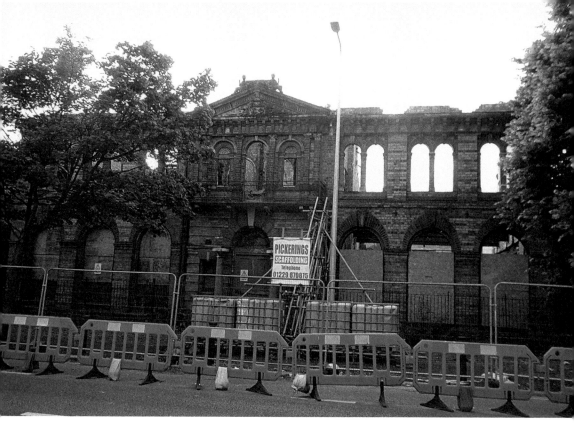

Above: House of Lords – a great loss of heritage.

Below: Barrow Girls' Grammar School – gone but not forgotten.

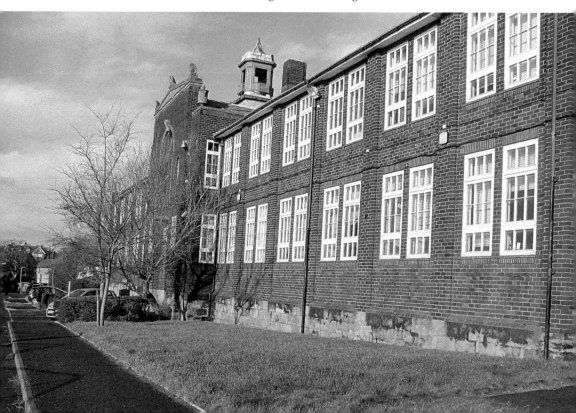

serve a modern police force; however, this glass-fronted, curvaceous edifice does not sing out 'police station' and it seems strangely less robust than what we were previously used to.

In conclusion, Barrow-in-Furness has always welcomed the innovative and new and prided itself in being forward-looking. So, perhaps we older Barrovians need to embrace this attitude and welcome new building and allow those not fit for purpose to slip away peacefully. After all, we can't ignore the town motto '*semper sursum*', or 'always rising'.

The 50 Buildings

Established in 1127 by the Savigniacs, this abbey was destined to become one of the largest and most important in the country. The first monastery was founded by Stephen of Boulogne and Mortain, later King Stephen. It was built in the Romanesque style from sandstone quarried from the valley in which it sat. The abbey grew rapidly and in 1147 the Cistercian order took over and eradicated the earlier style of building. The curved apse and presbytery became cruciform style. Although the reinvention of the abbey was thorough, there are still remnants

Furness Abbey, built 1127.

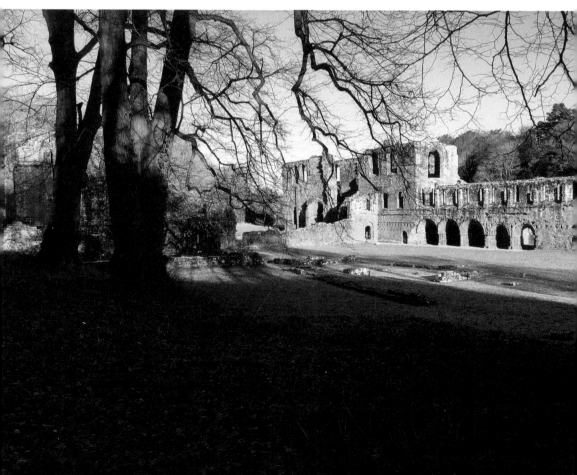

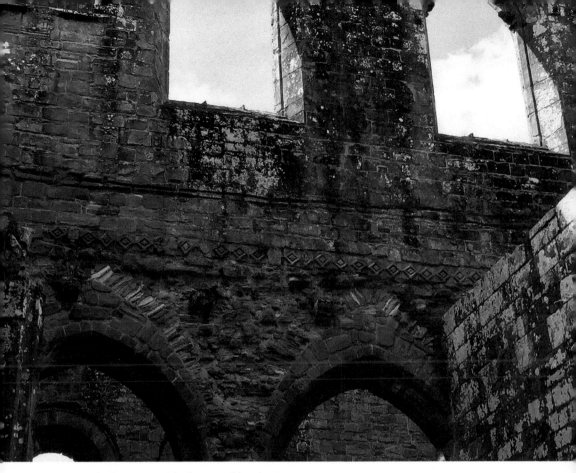

Detail of Savigniac blocks reused by the Cistercians.

of the Savigniac monastery visible – such as at the back of the presbytery where a line of diamond-shaped bricks has been reused and hidden from view.

The interior was limewashed white with red lines painted to represent bricks. The glass would be mostly clear, although small fragments of stained glass have been found, probably from the time when rules were relaxed and the style became more flamboyant. The abbey grew and was constantly modified to accommodate the needs of the population of monks and lay brothers. There is evidence of these changes clearly visible and one can observe the distinctive styles from the various periods. The building must have been imposing and a huge statement of power and status; the second bell tower alone stood at 160 feet.

At the Dissolution of the Monasteries the monks here had been reduced to thirty-four. The landholdings of the abbey were immense and once liquidated brought huge monetary gain to Henry VIII. The abbey was systematically destroyed, the roof lead melted, walls pulled down, glass removed and contents sold. The ruin we see is what remains not only after the king's officers had done their work, but after years of locals appropriating the stone for walls and buildings. Despite it being in ruins, this building is still visited and is one of the most significant in Barrow, which is why it must be included now. It has suffered from time and

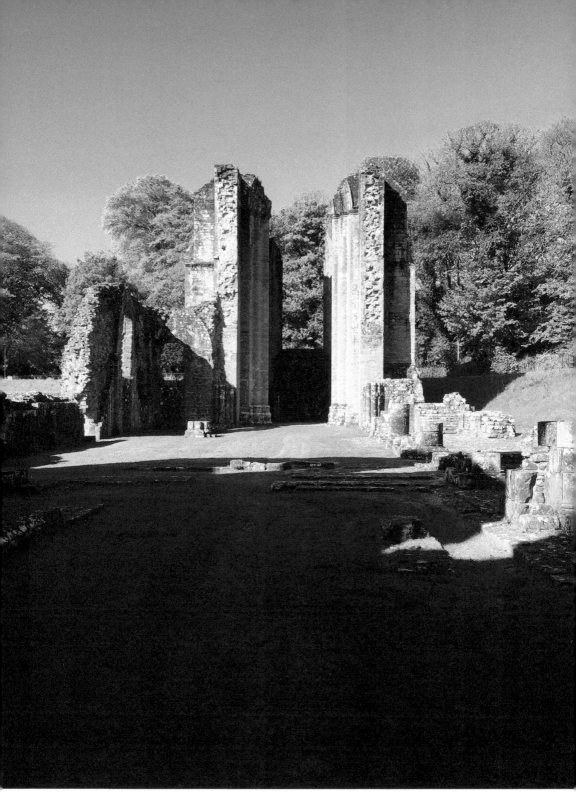

The bell tower, built 1500.

weather and English Heritage have worked tirelessly to rectify the subsidence that was spotted in the presbytery in 2007. A colossal steel support frame was added and the removal of the oak raft upon which the abbey was built has been replaced. The structure has now stabilised, but the frame will remain in place for a few more years. Ongoing conservation is planned for the next ten years, hopefully improving and preserving the existing fabric for future generations to enjoy.

2. Dalton Castle, Dalton-in-Furness

The pele tower that is visible is much changed from its original incarnation. It began as the judicial centre for Furness Abbey and was built in the fourteenth century. As lord of the manor, the abbot of Furness could preside over courts and there was a dungeon as well. The castle was a defence against the Scots in 1316 and later in 1322; it might have been here where Robert the Bruce parleyed with the abbot over terms for the safety of the Furness area. The building was built around and the marketplace housed the whipping post and stocks close to where

Dalton pele tower.

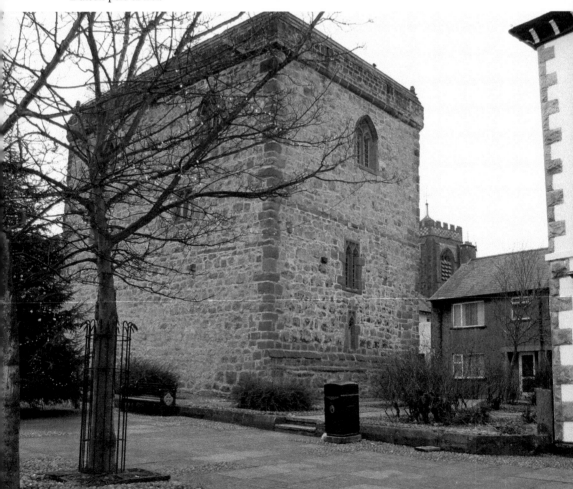

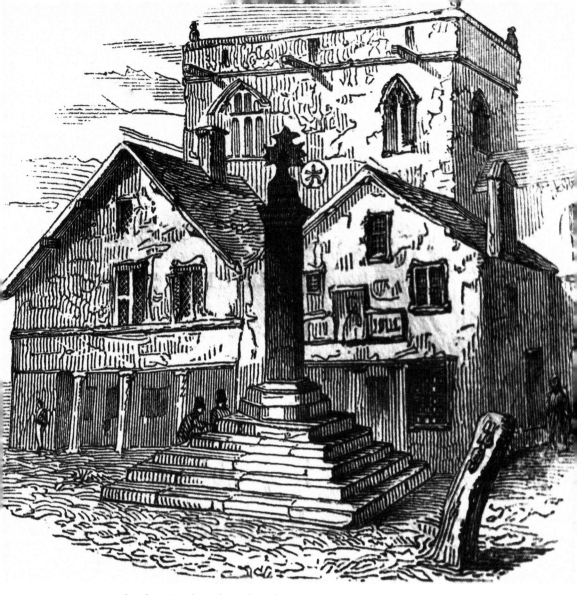

Engraving of Dalton Castle and Market Place.

justice was meted out. After the monks had gone the building fell into disrepair and was used as stabling. The houses around the pele tower are very old and one can see from the engraving from Jopling how the marketplace looked. In later centuries the castle was altered drastically by the Duke of Buccleuch, who owned it. Many features were removed and the current staircase and fireplaces were added. In 1869 the fish stones were added outside and the stock and whipping post removed. At this time the cross was replaced with a new one. The castle is quite imposing now that it stands alone on the market square and is administered by the National Trust. It houses a small museum with artefacts found locally. One can get an impression of the building when visiting, but the accuracy of this is limited by the changes it has undergone over the years.

3. Piel Castle, Pile of Fouldray

This medieval fortification is an exciting prospect for anyone visiting Barrow. It sits on a small island off the coast and is a popular destination for tourists. It is a sandstone and cobble construction that has a central keep, curtain wall, a gatehouse and towers. It was once an abbey holding and was built as a fortified storehouse and occasionally used by the abbot as a retreat. Its position was perfect for monitoring traffic sailing up and down the Irish Sea and was a good early warning post. The castle is probably fourteenth century and made use of the natural harbour at Barrow for exporting salt and wool. The abbot, John Cockerham, was given permission to crenelate in 1327 and the castle was in use

Piel Castle and island from Roa Island.

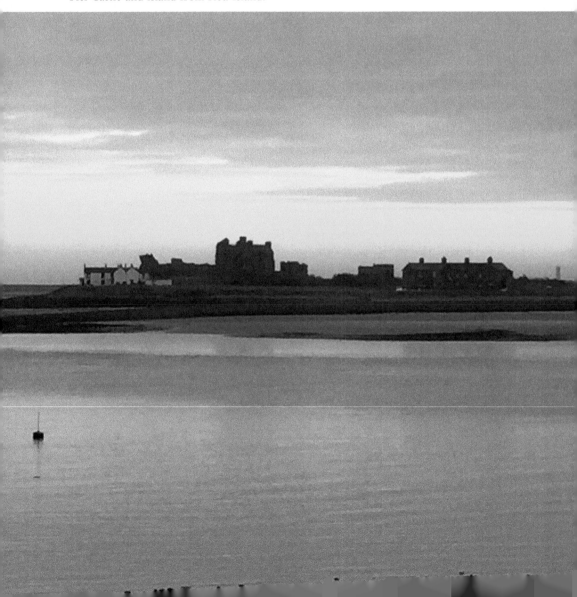

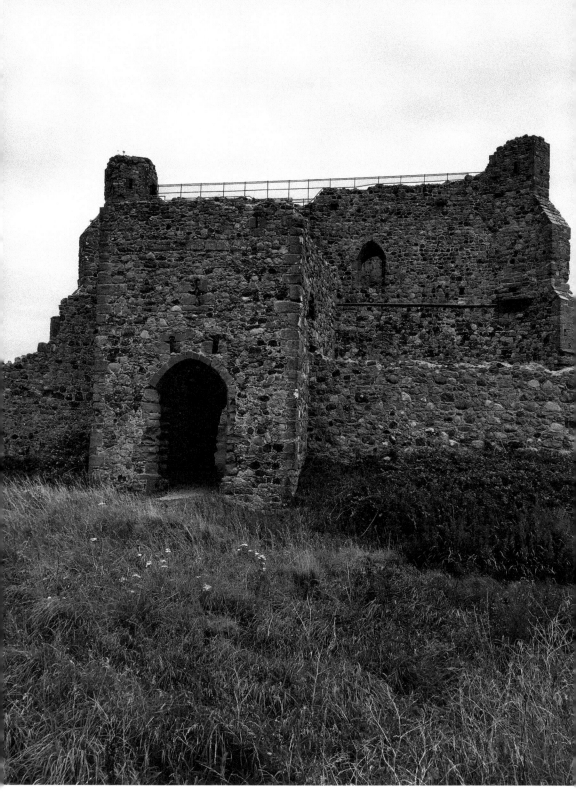

The Gatehouse at Piel.

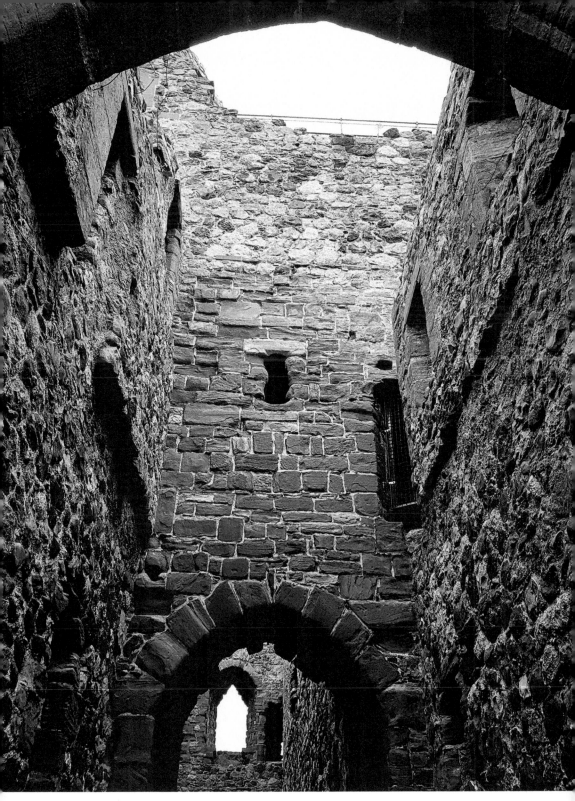

Inside the keep at Piel.

until the dissolution. There were various disputes with the Crown over excise duty and smuggling and it was taken under Crown control. It housed contraband goods such as Flemish wool on which the monks avoided paying duty, which they did habitually. It was brought to the attention of the Crown and it was seized by Henry IV. He was unable to use it and install revenue men because the monks removed the roof, making it uninhabitable. In 1487 the pretender to the throne, Lambert Simnel, landed at Piel with Martin Swartz and an army of mercenaries. They met with Henry VII's troops at Newark and were defeated. Rebel leaders were caught and executed, but Simnel was shown mercy and put to work in the palace kitchens as a spit boy. He later rose in status to become a groom and passed the rest of his life peacefully. The island was given as a war memorial to the town in 1920 by the Duke of Buccleuch and it is conserved by English Heritage as an open site. The castle is reached from Roa Island by ferry or can be accessed at low tide from Walney. A memorial plaque can be seen on the bank at Roa Island. There is a public house and a row of cottages that were used by the pilots and revenue men in the nineteenth century. It is a popular venue for families in the summer and people can camp overnight if they wish.

4. Roosecote Farm, Dungeon Lane

This farm has probably been the site of a settlement since early prehistory. It seems likely that, as the Roose area around it was populated and mentioned in the Domesday Book, the land has always been farmed. The farm was probably

Roosecote Farm, Dungeon Lane.

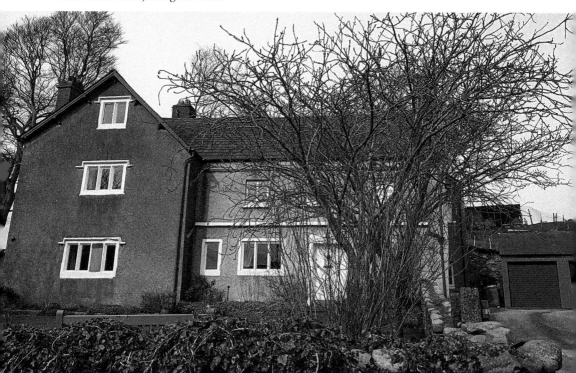

a grange for Furness Abbey throughout the Middle Ages and was recorded as such in a document from 1509. The buildings that exist now are old, with some elements of them dating to the sixteenth century but developed over the centuries following. One of the barns and the farmhouse are believed to date in part to the later monastic period, and later to the seventeenth century. They are Grade II listed. The details of the farm are sketchy because there is little written evidence in the historical record. Its name is supposed to derive from '*rhos*' meaning heath or moor and '*cote*' referring to a sheepcote – i.e. the 'sheepcote on the moor'. This would certainly fit with the idea of a small abbey grange engaged in breeding sheep and dealing in wool, especially with being so close to the road to the coast and Piel where wool was shipped from during monastic times. One can track almost constant settlement in the hamlet from the parish records, with the mention of many familiar local family names appearing. The farmhouse and barn have been subjected to archaeological surveys, including tree-ring dating. Some of the buildings are still a working farm and private dwellings, but one cottage has become a guesthouse.

Roosecote Guest House, Dungeon Lane.

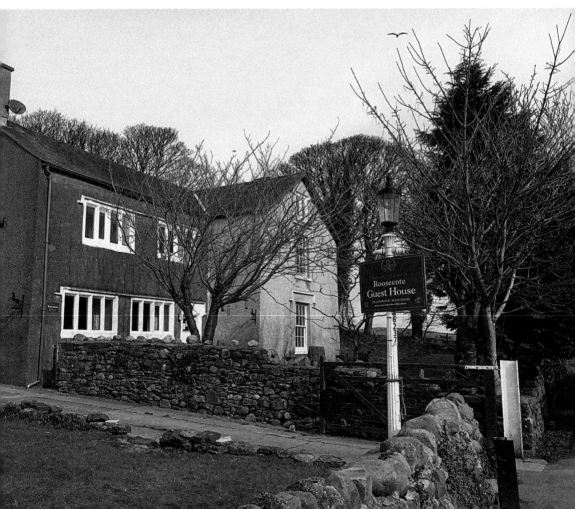

5. Queen's Arms, Biggar Village

Biggar is the oldest settlement on Walney Island. The Queen's Arms is a pub in the traditional farmhouse fashion and has retained many original features, despite some modernisation. It sits in its own courtyard and reflects its earlier use as a farmhouse. Its origins lie as an abbey grange and there are records as far back as 1292. The grange would have been administered by the lay brothers and later the local peasants would have rented the land from the abbey. Payments were often made in boon work – one such occupation being the repair and maintenance of the sea defences and dykes to protect the farmland from inundation by the sea. Biggar Dyke, a more solid construction, was built in the sixteenth century as a coastal defence for the village. The inn was probably built around 1600 and first appears in the historical record in the 1750s, marked as a beerhouse – probably as an extension to the farm. Later a tearoom was added, situated where the bar currently stands. By 1869 it was formally known as the Queen's Arms. It was bought by Councillor Hunter in 1879 and later in 1897 George Casson took over as the publican. The pub is a popular eating place and retains much of its earlier charm, with innovative events and activities planned by the owners. It is Grade II listed and allegedly includes timber from a ship from the Spanish Armada. It sports a spiral stone staircase and beams aplenty to add to the sense of history.

The Queen's Arms, Biggar.

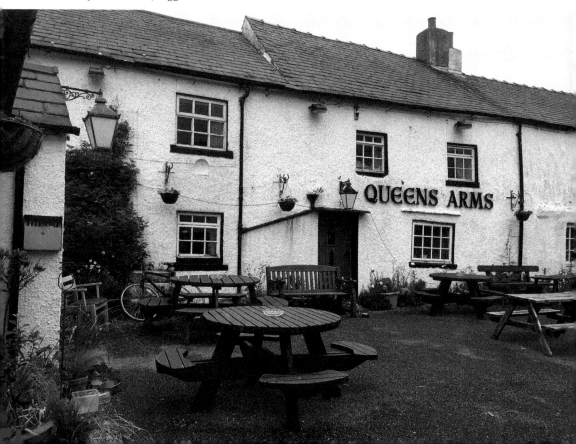

The barn at Queen's Arms, Biggar.

6. Rampside Hall, Hall Garth

This unusual building was constructed for the Knype family in the seventeenth century. It is listed and commands a view across the sands at Rampside. The family were descendants of William Knype, who was born in 1553, and they were leading Roman Catholics in the area. In 1649 the owner of both the hall and the associated 40 acres of scrub and woodland was a sequestered Papist John Knype. The house is a well-known landmark with its twelve chimneys – ironically named the twelve apostles – and has stood the test of time well. Unfortunately, its surrounding scrub and woodland has disappeared under a small estate of houses, and the house sits uncomfortably among them. It has three floors, plus a cellar and attic, and a large staircase with oak balustrades and handrails. Its array of windows is impressive, and the only changes externally are a replacement roof from 1810. The famous earthquake in 1865 was severe enough to bring down three of the famous chimneys and move some of the others. These were repaired and now stand as proud as they ever have.

Rampside Hall.

7. Romney's Cottage, Ormsgill

The noted artist George Romney lived here as a boy from 1742 at the age of eight until 1755. The cottage is seventeenth century and is Grade II listed. The cottage is in the area known originally as High Cocken and the garden faces the sandstone quarry, which is now a woodland walk. The cottage was elevated to importance in the nineteenth century when the Furness Railway advertised it as a tourist venue and developed it as an attraction. A small Romney museum was created and coaches brought people to visit. Romney is celebrated by a rather obvious wrought-iron sign across the front of the cottage, but it is no longer open to the public. The original entrance of the house is at the back, overlooking the garden, but the drive opens to the lane where once the coaches would have turned. The house has recently been on the market, advertised as an attractive family home and its quaintness is only surpassed by the views it commands. Romney was an acclaimed portrait painter who painted many famous people of his day, such as Emma Hamilton, Nelson's mistress. He is buried in the churchyard at St Mary's Parish Church in Dalton-in-Furness, famous, revered and a million miles from his early life at High Cocken.

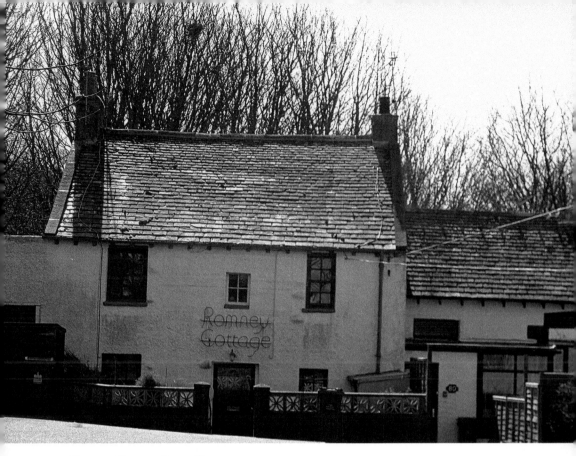

Romney Cottage, Ormsgill.

8. Manor Farm, Manor Road, Barrow

This farmhouse dates from 1845 and is at the junction of Rating Lane and Manor Road. The Victorian house is a large gabled, sandstone building that fits well with its ancient surroundings. Its location was part of the Furness Abbey manor and grange; there is some dispute as to whether the destroyed village of Sellergarth is somewhere close to its position. Ironically, the tenant farmer who litigated against Alexander Banke, the penultimate abbot of Furness, over the village's destruction was William Case. The resolution of the case is not recorded, but Farmer Case can be assured his name lives on and his descendant George Case holds the current farm. Manor Farm is a Grade II-listed building and has a rural setting. The farm consists of the house, farm buildings and a couple of small fields, most having been sold off. A battle to retain one field as agricultural land ensued in 2014 when proposals were made to build houses on it. The estate would have encroached within the conservation area and would have brought buildings to within yards of the Grade I-listed Abbey Precinct Wall and West Gate. This stirred up massive opposition locally and after a long fight the idea was turned down on appeal, thus retaining the calm and historic approach to Furness Abbey.

Manor Farm, Manor Road.

Inset: Manor Farm from the West Gate.

9. St George's School

This Church of England school was established in 1849. It is one of the earliest buildings in Barrow town and one of the first schools. It is typically made from local red sandstone and originally included a training college for engineers by Furness Railway for 'education of children and the moral and social uplift of parents', as Barnes puts it. The Duke of Buccleuch and Earl of Burlington defrayed the cost and the Furness Railway gave the plot of land to build on. The whole area around is of a similar building style and quality, with some changes made in later years. The school has been in constant use since its creation and doubled as a Sunday school. The structure is mostly intact, but to allow it to provide modern and appropriate accommodation for children, Cumbria County Council took the decision to refurbish and reorganise the building. The result is very pleasing: the integrity of this important early school has been retained, but the interior is modern and bright. The outdoor areas have been updated too, providing safe,

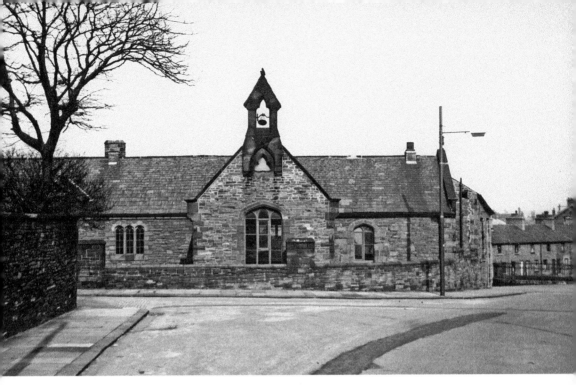

Above: St George's School.

Below: The newly refurbished St George's C of E Primary School.

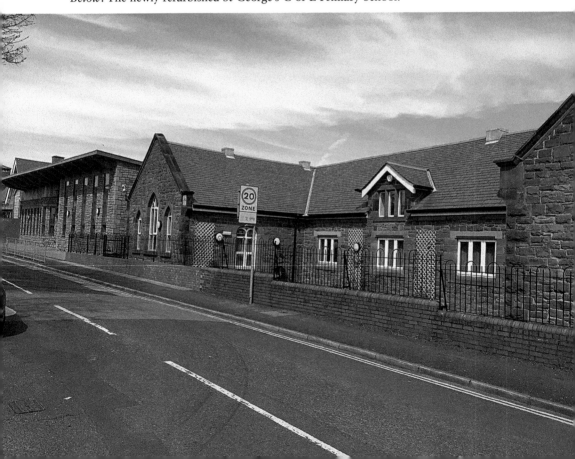

innovative playgrounds that offer more than the Victorian yards. The exterior has altered somewhat, though in a sensitive way. The later addition has been fronted by Burlington slate (the same as is used in St George's Church on the opposite side of the road) and provides an impressive entrance. This upgraded school is a haven for children and provides great support for one of the less prosperous areas of town.

10. Millwood

One of the significant nineteenth-century villas that has survived is Millwood. The house was built above the valley, which had once housed an abbey mill and from which it derived its name from. Originally, there was a seventeenth-century farmhouse on the site. It is believed that the large house was designed by Edward Browning of Stamford around 1860; this was modified and extended for Edward Wadham by Paley and Austin in 1876. Wadham was the mineral agent for the Duke of Buccleuch, one of the main investors of the new town of Barrow during the Industrial Revolution. It sat in the next valley from another house, Abbotswood, built for the Furness railway manager (James Ramsden) by

Millwood when first built.

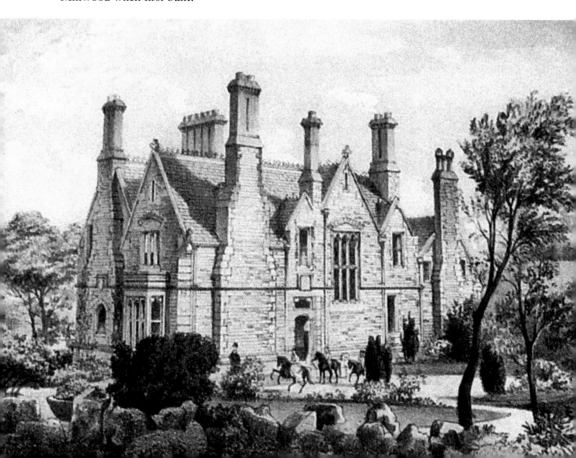

Millwood today.

the Furness Railway, owned by the Duke of Devonshire. The houses gave these two important employees a higher status and they were even afforded their own railway siding close to their homes to allow easy access to Barrow.

Millwood is a sandstone High Victorian Gothic in style and was appropriate for Wadham's status as mayor for 1878–81. The Wadham family lived there until the 1940s when the remaining member of the family died. During the Second World War evacuees were lodged at Millwood, as they were in many of these old rambling houses. The house was given over to a residential home for the elderly in 1947, but at least this meant it was safe from corporate destruction suffered by Abbotswood. The house was returned to private ownership in the 1980s. The manor is now separated into two distinct properties, one being a bed and breakfast establishment.

11. St George's Church, Barrow

Built on Rabbit Hill in 1859–60 and consecrated in 1861, St George's is the oldest church in the town. It was designed by E. Paley and built from slate quarried at the Burlington quarries at Kirkby and sandstone from St Bees. The north aisle was added in 1867, which increased the capacity of the church to 1,000. It dominates the top of the hill and stands as the civic church for the town. Donors such as the Duke of

Devonshire and Buccleuch, Henry Schneider, Hannay & Co., and Harrison and Ainslie & Co. were responsible for the financing of the project, and it was seen as an important addition to the new town. It became the first parish church that was Anglican and it was a few more years before a Roman Catholic church was built. Sir James Ramsden influenced the building of the church and a chapel in his name was built with its own special doorway for Ramsden and Lady Ramsden to access the church in 1883.

The choir stalls are ornately carved and are deliberately designed to demonstrate the high status of those using them. They are still used in municipal events. The chapel was again designed by Paley and Austin. At the altar on either side of the chapel are two carvings of Ramsden and his wife, indicating his idea of his own self-worth, raising him almost to the level of medieval sovereign. The church, like many others has been partitioned and sectioned off to be a more appropriate space for declining congregations, but the main elements are still retained. The church has no graveyard and its north aisle is now a church hall. Although still imposing, it is now on the edge of the town, following the shift of the centre when the railway station was moved to its current position.

St George's C of E Church, Barrow.

Bell tower, St George's Church.

12. St Peter's Church, Ireleth-in-Furness

Known as the 'Iron Church', this simple place of worship was dedicated on St Peter's day, 29 June 1865. It was built using the profits from for the local iron ore mines and to provide a church for a growing congregation. Ireleth village is mentioned in the Domesday Book as a settlement and remained a small village until the nineteenth century, when the population began to grow because of iron ore mining. Askam village grew rapidly as the industry developed but the church was built in the older Ireleth village. It has an imposing position above the villages and the views across the Irish Sea and Duddon estuaries are breathtaking. The sandstone church is very simple, with a wide nave and small bell tower and porch. Inside there are stained-glass depictions of St Peter, Christ and the Virgin Mary, made by Shrigley and Hunt. The church is relatively unchanged and has seen generations of families baptised, married and despatched here. It is surrounded by a churchyard that travels down the steep hill – some of the gravestones are as old as the church and unfortunately have become dangerous in places. The municipal

St Peter's Church, Ireleth-in-Furness.

Inset: St Peter's from the west.

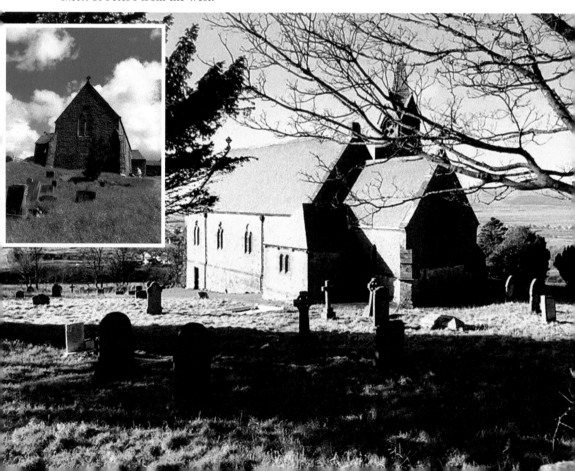

graveyard is next door, and many choose to be interred there rather than in the old churchyard now. The churchyard is cut only a couple of times a year to encourage wildlife and there is an amazing display of seasonal flowers through the year.

13. St Mary's RC Church, Duke Street

E. W. Pugin, the renowned architect and Roman Catholic convert, designed this church. It was completed in 1867, a few years later than the Anglican parish church at St George's. He was noted for his neo-Gothic architecture, including the design of 100 Roman Catholic churches. The necessity for a Roman Catholic church became apparent because of the influx of Irish workers on the docks and

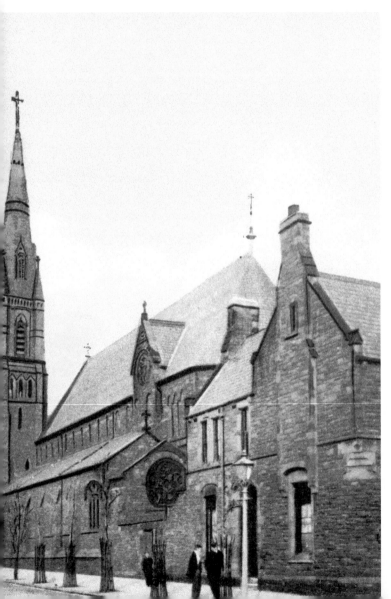

St Mary's RC Church.

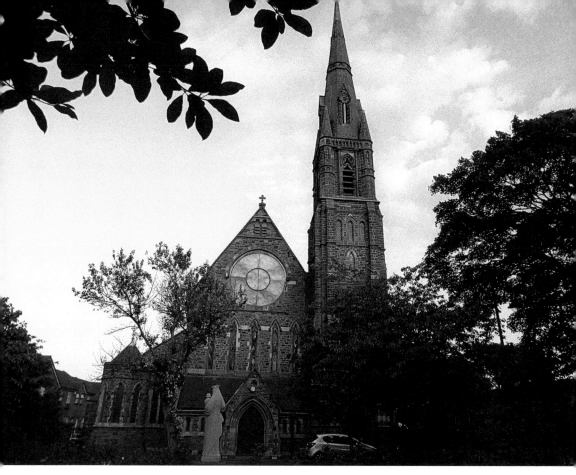

St Mary's from Duke Street.

railways; they originally had no facilities and had to make do with a temporary place of worship in a building in Greengate Street. Land was donated by the chief employer of the Irish workforce, the Duke of Devonshire, who helped to fund the construction. The architect obviously anticipated a large congregation because the church had a capacity of 800 seats; this was extended later and it now accommodates 1,000 people. St Mary's impressive spire was added later in 1888 and it is a prominent feature on the town's skyline, being visible for miles.

It is a Grade II-listed building and is still in constant use. In recent years it has needed work to conserve and repair the steeple and was awarded grants from the Heritage Lottery Fund to undertake these in 2015. More Roman Catholic churches and schools were built in subsequent years, such as St Patrick's, Barrow Island, built in 1877 and rebuilt in 1933. The school chapel of Sacred Heart, near Salthouse, was built in 1902. Further RC churches opened at Newbarns (Holy Family) in 1951 and Ormsgill (St Pius X) in 1957. St Mary's originally had a Roman Catholic school attached, built on land given by Sir James Ramsden in 1872. This school was eventually abandoned in favour of two new schools, Holy Family at Newbarns and St Pius X at Ormsgill further out of town in 1974 and next to their churches. A Roman Catholic preparatory school, which

was a forerunner of Chetwynde School, opened at Crosslands 1945. There is now a strong Roman Catholic heritage in the town, principally due to the changes wrought by the Industrial Revolution and the mass movement of populations seeking work.

14. The Custom House, Barrow

This is one of the most attractive buildings in this area and it has survived well by adapting its use. It is in the Italianate style and stands out among the heavier designs from the late nineteenth century. The four-storey building stands proudly at the junction of Abbey Road and Hindpool Road, its address being No. 1 Abbey Road, and marks the boundary of the 'old to new'. Across the roundabout is the modern Cornerhouse Retail Park, with its large stores and supermarkets brandishing their brash signs at this heritage gem. The Custom House was originally built as a hotel in 1870 called the Imperial Hotel and was altered to become the government building, which housed the custom house in 1873. It regulated custom from the port of Lancaster and later became a post office. It

The Custom House.

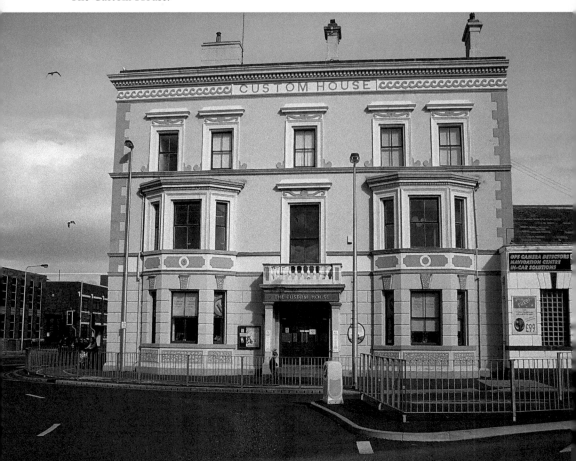

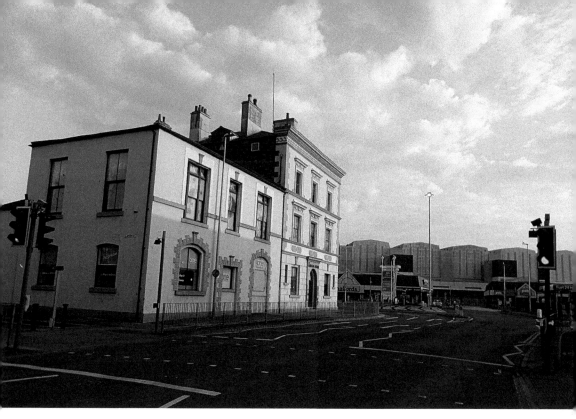

The Custom House from Abbey Road.

was well known as St Mary's Club for many years, but kept the bold lettered sign declaring it was a Custom House. It was listed as a Grade 11 building in 1976 and has since been converted to a restaurant, Playzone for children and Lazer Zone. It has retained some of its interior features and is still impressive externally. Its location is unfortunate, but it is in a prominent position.

15. St Paul's Church, Hawcoat Lane

Built in 1871, this Victorian Gothic church built by Habersham & Brock has changed dramatically. The sandstone exterior still gives an idea of what it was once like, but there have been various additions and alterations, which are very different to its older style. It was damaged during the Second World War when bombs hit the residential area around Hawcoat Lane, Hollow Lane and Prospect Road. However, some would say this was minor in comparison to the post-war alterations made in the 1960s and later in the 2000s. The church was extended with a flat-roofed porch and entrance in 1967, but the integrity of the inner church was retained. A new pitched slate roof extension with a large bay window on the gable end was constructed in recent years. The external impression is an improvement on the 1960s version and provides space inside for community gatherings and meals. However, the nave has been altered

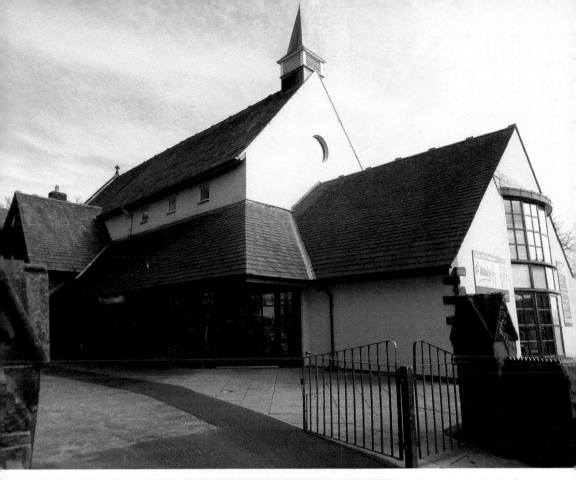

Above: St Paul's C of E Church, Hawcoat Lane.

Left: St Paul's from Abbey Road.

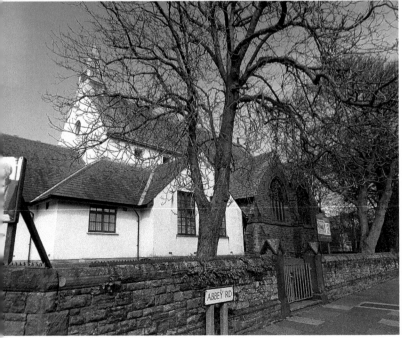

drastically, pews being removed, and the church furniture and layout simplified and modernised. This change proved too much for some of the older members of the congregation, but it cannot be denied the space is a more adaptable, if less traditional, one.

16. Ramsden Hall, Abbey Road

In 1872 James Ramsden gave the first public bathing facilities to the town. Above the entrance of this Grade II-listed building on the segmented arch is a carved ram's head. This symbol was Ramsden's own and it appears in various buildings through the town, including St George's Church, the cemetery and the town hall. The inscription says, 'Presented to the town by James Ramsden Esquire First Mayor'. The baths were state of the art and had three bay arcades with wooden posts and arch braces – all now removed. Ramsden Hall ceased to provide bathing facilities and was converted to a public hall in 1886 when new facilities were created. The building later became an annexe of the technical college, which was built along from the baths, becoming an art studio. It now provides space for the Citizen's Advice Bureau. It hints at it original use with the surviving tall chimney, which is obviously now no longer in use. It is one of the landmarks along this section of Abbey Road and has survived better than its contemporary buildings such as the House of Lords, which burnt down in 2017, another Victorian edifice.

Ramsden Baths.

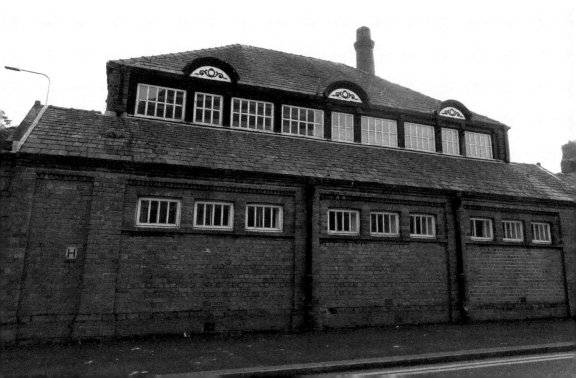

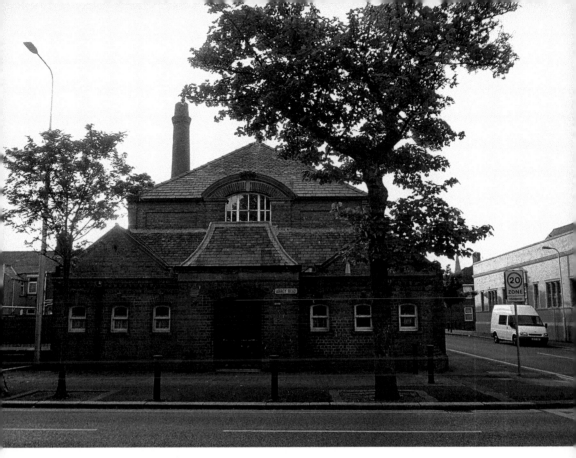

Ramsden Hall Public Baths.

17. Roman Catholic Chapel, Barrow Cemetery

Built in 1872, the chapel was most likely designed by Paley & Austin to provide a chapel of ease for Roman Catholics. The chapel was constructed at the same time as the gatehouse and north lodge. The development and growth of the cemetery was in response to the rapidly growing and diverse population of Barrow. The original chapels of rest and burial grounds were no longer adequate at Dalton and Walney. It is situated at the back of the cemetery in a section reserved for the Catholic population. The building is limestone with red sandstone dressings, it is in a cruciform plan, with crossing tower and is Romanesque in style. Although it is Grade II listed it has fallen into disuse and is sadly boarded up. The chapel is surrounded by the graves and memorials of Roman Catholic families, including one to the parish priest Father Caffrey. This monument was paid for by his parishioners at St Mary's in recognition of his work among the poor in the community. He was an Irishman and understood well the needs of his fellow Irish parishioners; he worked hard to support and educate them and was instrumental in establishing the faith schools and later the convent. He is remembered by the prominent monument just in front of the chapel.

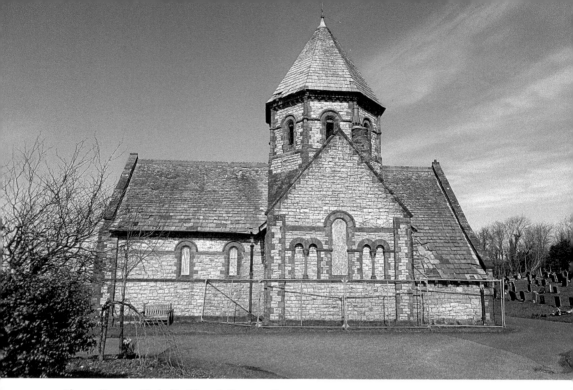

Above: Roman Catholic Chapel, Barrow Cemetery.

Below: The Caffrey monument.

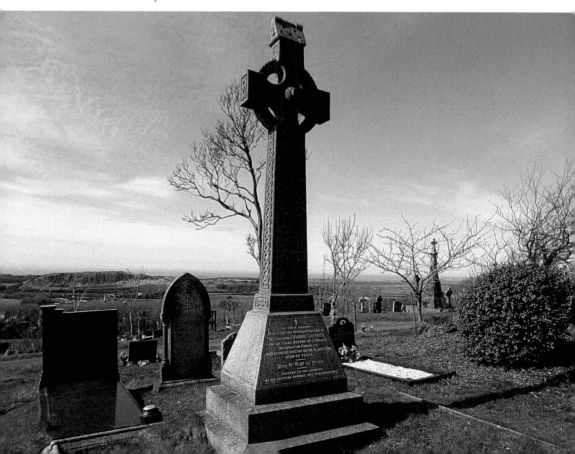

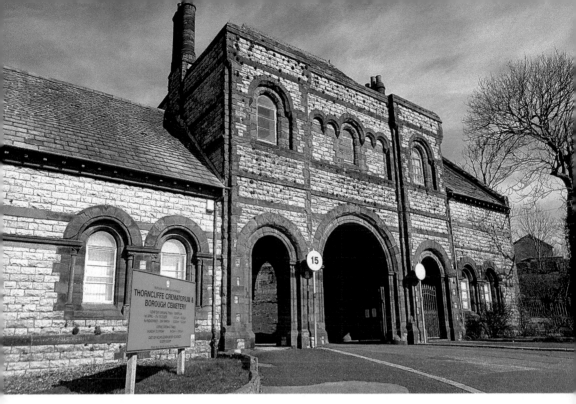

The cemetery gatehouse.

18. Barrow Shipyard (Vickers/BAE Systems), Michaelson Road

Furness has always been known for shipbuilding, even in early times. Samuel Pepys, who worked for the Admiralty, made mention of it in 1667 when he surveyed Piel Harbour for its suitability to build warships. Most vessels built here would be for local use: for fishing, travel and carrying goods. Ulverston became a prime place to build ships and the new canal supported this. However, this ceased by 1878 because of the ascendancy of the Barrow shipyards. William Ashburner was an Ulverston shipbuilder and he transferred to Barrow in 1847 as shipbuilder and repairer. This was the perfect time because it was at the advent of the industrialisation of Barrow. He was responsible for the construction of the *Jane Roper*, a schooner built in 1852. The first yard and slips were roughly where Devonshire Dock is; later the yard moved to Hindpool and he built twenty vessels between 1852 and 1878. Joseph Rawlinson opened another successful yard in 1860, which was later sold to James Fisher, who expanded the firm greatly. In 1870 the Barrow Iron Shipbuilding Company was established on Old Barrow Island, transforming the Michaelson estate into a hive of Victorian industry with austere workshops and living quarters for the workforce. The first ship, *Aries*, was built in 1873 for Sir James Ramsden, who also became managing director two years later. The first warships were built in 1877 and in 1881 a liner named the *City of Rome* was built. The business developed and grew, which in turn lead

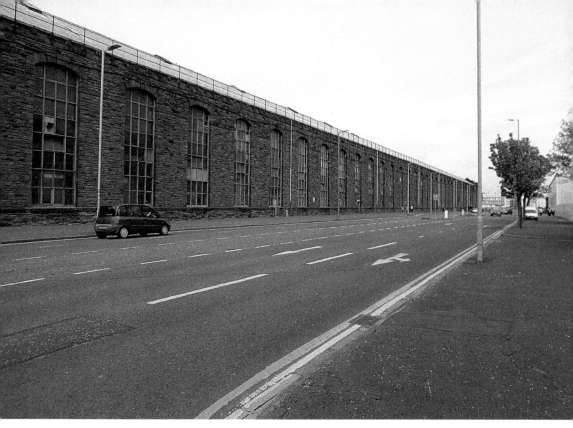

Above: Shipyard buildings, Michaelson Road.

Below: Victorian shipyard buildings.

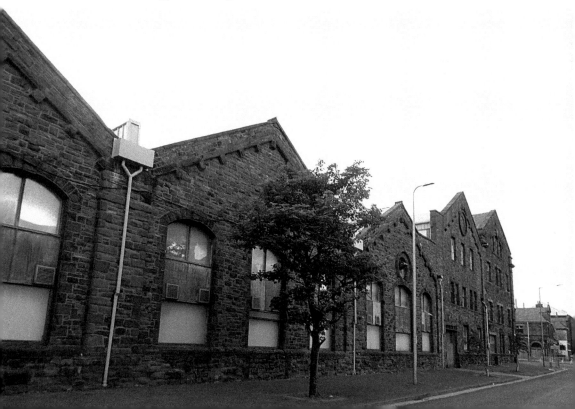

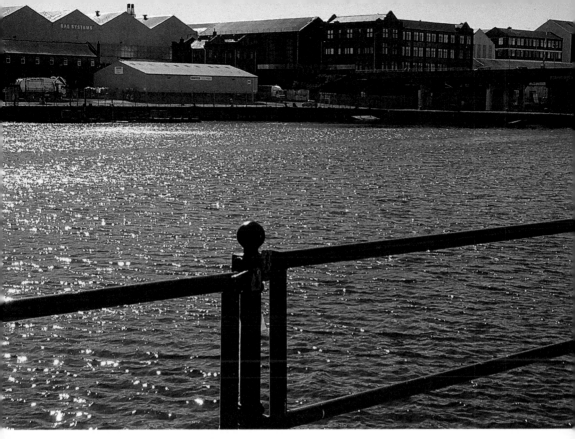

BAE Systems from Buccleuch Dockside.

to the development of the dock system. In 1886 a steam-driven submarine, the forerunner of Barrow's specialist submarine building, was launched. The yard became prominent in both shipbuilding and armaments and heavy engineering and in 1896 the company was bought by Vickers & Sons & Co. The shipyard has changed hands many times since and has diversified to remain viable. It is still one of the largest employers in Barrow, despite periods of boom and bust, strikes and lay-offs. Its future currently looks rosy, due to being awarded the contracts for the Successor class submarines. The investment is positive for the town and the building to house the construction has already been built.

19. Furness Abbey Cottage

The Grade II-listed cottage is a beautiful building that has been sensitively modified and extended. It was originally built in 1873 for the Furness Railway as a coachman's house for the Furness Abbey Hotel. It is constructed from red sandstone and is a two-storey building. There are other single-storey buildings too, some of which follow the imprint of the old stables that were demolished. The house has been doubled in size, again following the original footprint of the old coach house. The current building has incorporated the old one and presents

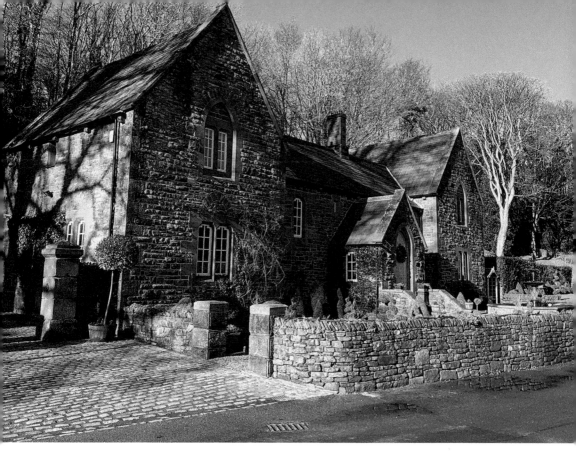

Furness Abbey Cottage, Abbey Approach.

a sympathetic and attractive alternative. The topiary garden in front enhances the look of the building and it dominates the space in front of the Capella ex-portas (a monastic ruin) but does not detract from it.

It is thought that an earlier building was on the same site prior to 1873 – probably as early as 1843. It is unknown what the building was, but it seems likely it was swept away with the advent of the railway and the building that ensued. It might have been linked to the early railway or the hotel, perhaps housing people connected with the company as a temporary measure.

2c. The Washington Hotel, Risedale Road

This building has recently undergone a massive transformation by developers. Its use as a public house had ceased in recent years and the building had fallen empty. The pub in its heyday was a busy and thriving one, having been built by local builder William Gradwell in 1874 at a cost of £4,000. It was given a full licence in 1875 when the hotel opened. The name arises from the commemoration of American Independence, as did the White House Hotel on Abbey Road (now demolished). After going to auction at various times the pub was purchased by the

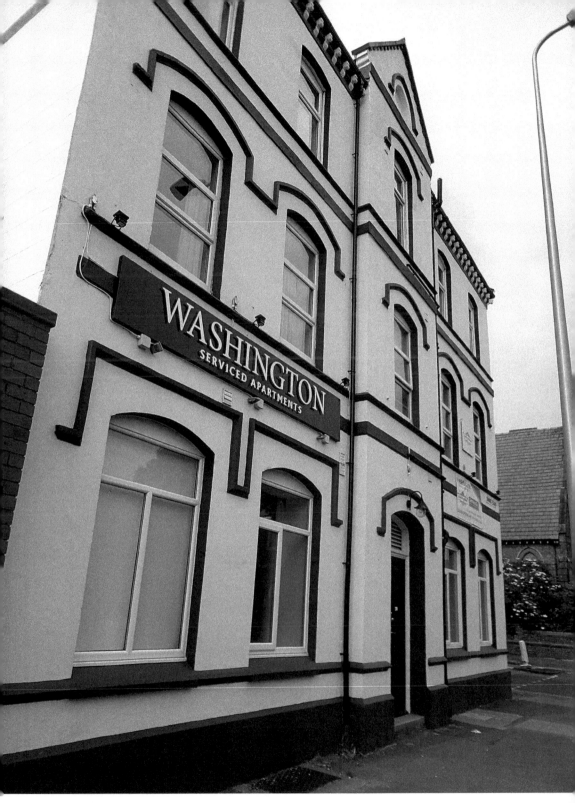

Washington public house – now apartments.

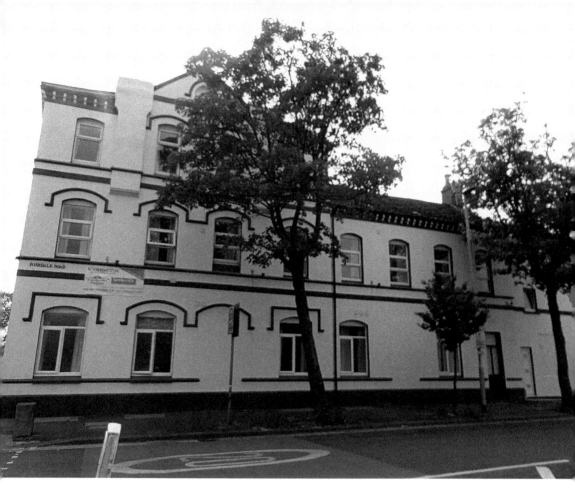

Washington apartments.

local brewery Case's in 1897. It cost a mere £6,500, which is hardly comparable with its worth today. The pub served a large urban area and it was placed prominently at the junction of two main roads, Risedale Road and Salthouse Road. It was a popular pub and at one time it had a bowling green and later a children's play area. It was a local landmark and was known as the 'Wash' – the bus stop close by was identified by this name. The current refurbishment has been sympathetically done and there are now serviced apartments available for 'professional' people. This probably is in response to the recent award of contracts at BAE Systems, which will mean an influx of contractors to the area.

21. Barrow Public Library

Even from the early days of the town there was rudimentary library. The original one began its life in a tin hut in 1882, but this was soon removed to the town hall as a more permanent home. As the population rose the need for an independently housed library became clear, and in 1915 the new library was built. Its completion

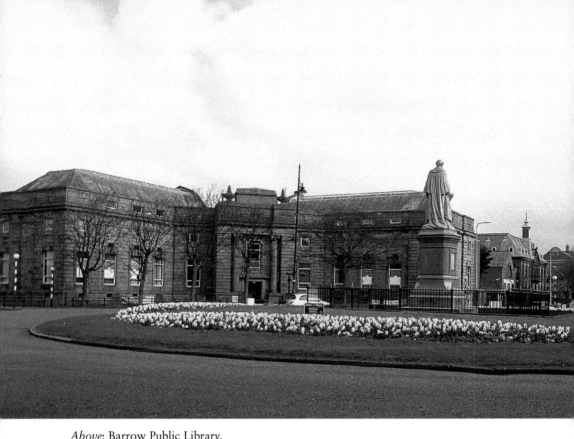

Above: Barrow Public Library.

Below: Barrow Archives.

was not until 1922, however, and one can see why when looking at the building now. It is a grand structure, built in the Beaux Arts style, which was popular for civic buildings at this time. It stands on the corner of Abbey Road and Duke Street, an imposing and attractive construction that dominates and enhances the square. It complements the other buildings opposite, which are grand and imposing structures too, but it has a slightly incongruous neighbour across from it. This part of the square once housed the Jute Works and is now a retail outlet and bus layby. The library is still very much in use and is as decoratively pleasing inside as out. Originally the upper floor, reached by a sweeping curved staircase housed the reference library and a museum. These flanked an open landing and were reached through glazed doors. The reference library was formal and had wooden desks and seating for people to study. This area is now used as staff offices and storage, as is the museum. The museum was an early attempt to display items of local historical interest, with a few anomalies like a moose's head and a mummy's hand, their removal into storage being much mourned by those of us who pored over these exhibits on wet Saturdays. The old-fashioned museum was replaced by the Dock Museum. This doubtless presents a more modern and accessible display, but it hasn't quite got the mystery and quirkiness of the glass cases and weird, wonderful and extremely radom objects. The Barrow Borough library ceased to exist in 1974, following the administrative boundary changes, and was taken over by Cumbria County Council, who still administer the library service. The library has had a refurbishment and upgrade in recent years and it provides electronic self-service, a children's library, computer suite and a separate extension housing the Local Studies Library and Archives.

22. Devonshire Buildings, Michaelson Road

Once mass industrialisation had begun, the need for worker's accommodation became increasingly important. At the beginning workers had been given makeshift, temporary buildings that were overcrowded and insanitary, like the Black Huts. Disease was rampant, and the town fathers realised that better accommodation was necessary. Devonshire Buildings, as the name suggests, was built by the Duke of Devonshire to house his workers from the shipyard and docks. The buildings were constructed in the 1870s and were designed by Paley & Austin, the popular architects from Lancaster. They were based on tenement-style buildings as can be found in Glasgow and at the time were state of the art. They provided a decent, secure and modern living space for the workforce and ideally the landlord was also the employer, providing a lucrative system whereby the tenants paid rent with wages earned at the yard. The position of the buildings is central to the complex of shipyards and made the journey to work very short. The buildings are made from local sandstone and although their appearance is austere, they are quite attractive and have

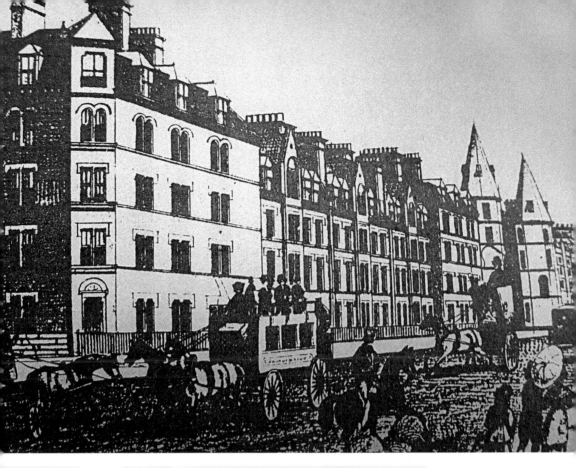

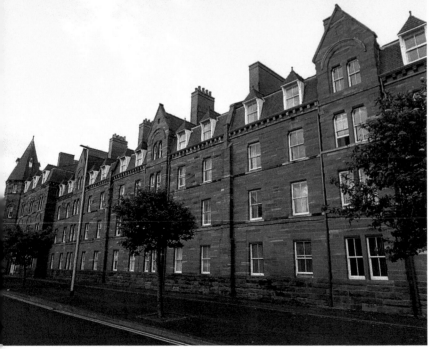

Above:
Engraving of
Devonshire
Buildings.

Left:
Devonshire
Buildings,
Michaelson
Road.

octagonal towers at the end of each block. They are now Grade II-listed buildings and although they fell into disrepair in the later twentieth century, Holker Estates have now refurbished them to a high quality and they include all the modern requirements and conveniences. They are prominent on Michaelson Road and sit comfortably among the Victorian Shipyard buildings – a far cry from the original rurality of Barrow Island and the Michaelson estates.

23. Roose Primary School, North Row, Roose

Situated in the centre of Roose village, the school is a prominent and important building. It is still very much in use and has been extended to accommodate the growing population of children. It has a nursery and day-care centre and although changes have been made to the building the original Victorian edifice is easy to recognise. In 1870 the Education Act allowed the setting up of school boards and in 1872 the Barrow School Board was established, causing a rash of building. The school was built in 1875, at the same time as Barrow Island, Holker Street, Cambridge Street and Hawcoat. It was a permanent structure and served the mainly Cornish community at Roose. It has fared better than some of its contemporaries, retaining its original bell tower and Victorian style. Internally, it has classrooms running along a long corridor, but with new

Roose Primary School, North Row.

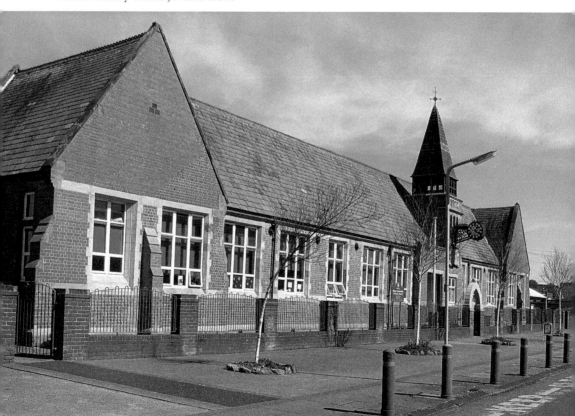

Roose School war memorial.

adaptations and extensions. The school hall was added in the 1960s and is a large, bright and airy room, and the nursery building was added when the offer was extended to pre-school children. On the edge of the school field is the 'Baby Room', which is a day nursery for the very young. The old dinner canteen has been demolished and replaced by a sensory garden and the playgrounds have been adapted to accommodate outdoor play and staff parking.

An unusual and touching piece of local history is encapsulated in the Roose War Memorial clock, commemorating those who served and died in the First World War. It is unusual in remembering the sixty-seven survivors as well as the eight who perished during the conflict. It was installed in 1921 by Frederick Diss & Sons, who owned Storey's the Jeweller in Barrow. The clock was restored in 2009 and has an accompanying plaque.

24. Cooke's Building, No. 104 Abbey Road

Built in 1875 and designed by Howard Evans, this High Victorian Gothic building is Grade II listed. It was the premises for H. Cooke & Sons right up until 1959 when the company was liquidated. It had been a furniture store until that time. It became variously a music shop, a nightclub and is now a studio for the creative

Cooke's Building, Abbey Road.

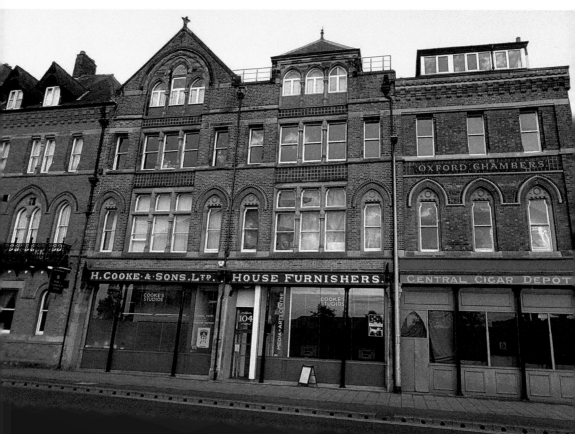

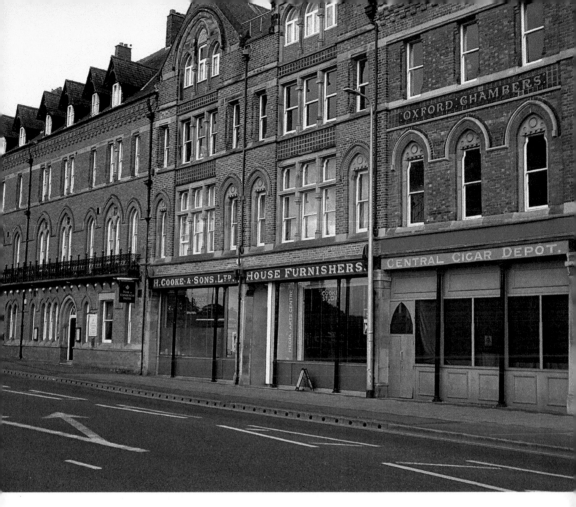

Cooke's Building, Oxford Chambers and the Duke of Edinburgh.

arts. It is a five-storey building, including an attic space and cellar, and is next to other similar listed buildings. It was secured in 2007 as part of the Townscape Heritage Initiative run by Barrow Council and funding was acquired by various arts groups from Heritage Lottery Fund and a Community Assets Fund to completely refurbish and reimagine the building. The building was brought back into use, with many original features being retained such as the central staircase, brickwork, woodwork and metalwork exposed to produce a contemporary industrial setting. The original advertising signs were repainted by professional signwriters and this detail enhances the building even further. Signal Film & Media, Ashton Theatre Group and Dare Dance were all involved with Barrow Borough Council to create a modern usable space within a heritage building, and the balance is just right. It provides accessible and innovative facilities with all modern expectations, such as a lift, yet retaining the Victorian aspect perfectly.

25. Trinity Church, Abbey Road

This imposing church stands along the main tree-lined avenue, Abbey Road, into Barrow. It is one of the surviving Nonconformist churches, of which there were once many. It was founded in 1876 at the peak of the population rise and was typical of many of the early temporary churches in Barrow at the time. The Wesleyan chapel was an iron-built structure, never meant to be used long term, and in 1902 the current building was constructed. The church cost £9,000 to build and it was a dramatic change from the iron hut that it replaced. The building underwent changes again in 1991 when the United Reform Church on the corner of Abbey Road and Ainslie Street was demolished. The congregation was accommodated within the Methodist church and major alterations were made. The original church was split and an informal centre for events was created within the building. The carved altar screen that was behind the altar in the church has been moved and is still visible in the centre. This church supports many events and is at the centre of the local community; it hosts church groups, Brownies and a variety of societies, including the Civic and Barrow History Society who use it regularly, contributing to its ongoing success.

Trinity Church, Abbey Road.

26. The Crow's Nest, Barrow Island

This public house is a typical working-class Victorian pub. Built in the 1880s, it could not have been situated closer to the shipyard; the old train lines ran in front of it and the workforce would have passed it daily. The nautical name fits with the shipbuilding history, though its clientele was probably mainly shipyard workers rather than sailors. Its red-brick construction is attractive and its walls curve around the corner of the street, giving it a prominence among the terraced housing it is surrounded by. It is one of the many pubs built to service a thirsty manual workforce and has survived many of its contemporaries. At one time it was suggested that Barrow had a pub on every corner, and this, of course, was one of those. Ferry Road runs past the yard but is flanked by rows of modest terraced houses, bringing the proximity of the pub close to where its customers lived. It recently found fame when it was featured in both book and film by J. K. Rowling, a Cormoran Strike tale called *Career of Evil*. As can be deduced from the title, the portrayal is not a very happy one and the emphasis is on the post-industrial deprivation and crime prevalent in the area. Rowling

The Crow's Nest, Barrow Island.

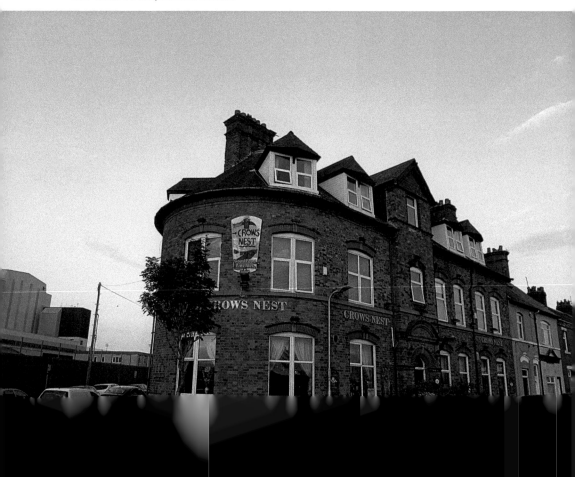

apparently spent a day in Barrow to research for the book and there are many other aspects and locations mentioned that will be familiar to the residents. The Crow's Nest is still popular with locals and will likely endure for many more years.

27. Town Hall

Construction of this civic building began in 1882, following an invitation to architects to design a town hall worthy of this new borough. The Grade II-listed building is spectacular and reflects the confidence and self-belief of the town fathers, who believed Barrow could become a significant and important town to rival Liverpool and Manchester. It stands at 50 metres (164 feet) tall and is an imposing Victorian Gothic edifice, as grand as any other of this style and time. William Henry Lynn won the contract to build the town hall and his designed was approved. The original clock tower had to be redesigned and rebuilt; the original stone used was a sub-standard sandstone found locally, which had caused cracks to appear. The problem was rectified, however, and the clock tower remains its crowning glory. It is constructed from red sandstone and Westmorland slate. The town hall was opened in 1887 by Spencer Cavendish, 8th Duke of Devonshire, coinciding with Queen Victoria's Golden Jubilee.

The interior is as grand as the outside. The Queen's Hall adorned with stained glass commemorates William Cavendish the 7th Duke of Devonshire, Lord Frederick Cavendish and Lord Edward Cavendish. The upper floor is divided into the council chamber, public and press galleries, the drawing room, the anteroom and the banqueting hall. The building is packed with artefacts that are part of the town's heritage and form an eclectic mix – from biblical carvings allegedly from Furness Abbey to a Satsuma bowl from the visiting Japanese in 1900 to commemorate the launch of the *Mikasa*. There is a selection of furniture rescued from Abbotswood, the home of Barrow's first mayor James Ramsden, artwork and many other interesting artefacts.

The town hall is still in use and in recent times council employees have been drafted back from other buildings to work in the newly refurbished offices in the municipal building. There has been much dispute about the correct orientation of the town hall. The 'front' is facing the Forum theatre and Market Hall – the main entrance is gated and shows the date of its opening. The 'rear' is an attractive sight and one can see the confusion: it used to face the Public Hall and the Victorian covered market, which was destroyed many years ago in preference of a municipal car park and garden. There is a statue of Sir Frederick Cavendish (moved when changes were made to Cavendish Square), which had been in front of the town hall. A paved plaza was laid in front of the town hall and it has improved the aspect by removing the buses and traffic that used to drive in front of it.

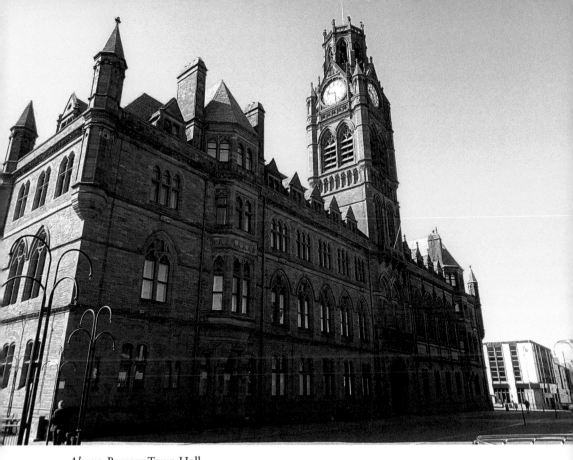

Above: Barrow Town Hall.

Below: Barrow Town Hall from the rear.

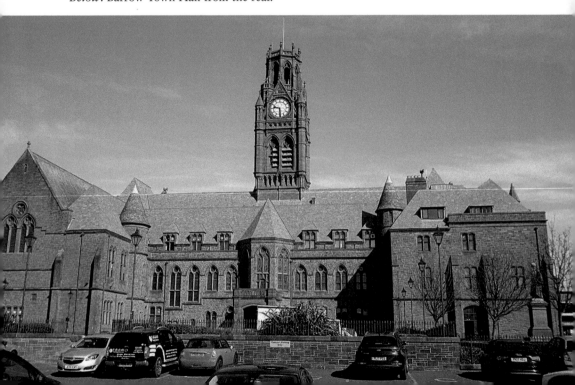

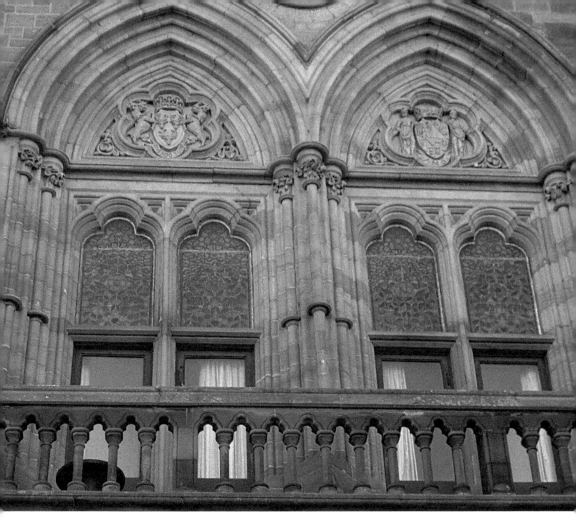

Barrow Town Hall's balcony.

28. Victoria Hall, Rawlinson Street

Previously the Sunday school for St Mark's Church, this building has been changed to provide modern accommodation for a variety of businesses and uses. It was built in 1888 by Paley & Austin in red brick. There is still a plaque with 'St Mark's Sunday School 1888' and 'Victoria Hall' engraved over the door. There are some leaded stained-glass windows depicting biblical figures, echoing the original religious use of the building. The interior has been greatly modified and renovated to be fit for its modern purpose. There is a large hall that is suitable for events and exercise classes, and 13,500 square feet of offices available to small businesses. Modern additions such as a lift and disabled access and toilets are also part of the new infrastructure. It is still an impressive building and dominates the street view. It is gratifying to see the way this building has reinvented itself and is still a centre of the community, which should protect its existence for years to come. Its partner building, St Mark's Church, has also

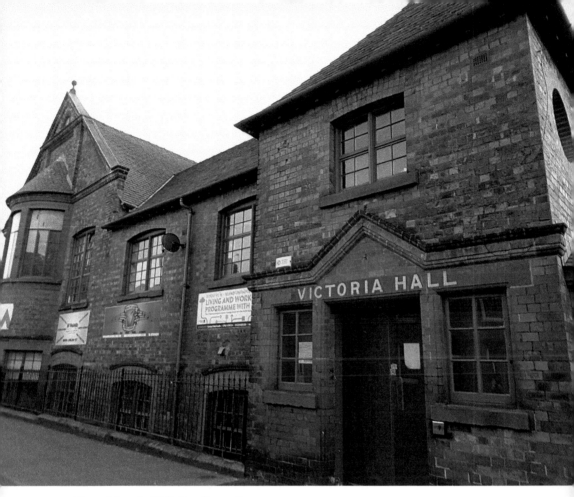

Above: Victoria Hall, Rawlinson Street.

Below: St Mark's Church.

survived with numerous alterations. It is situated around the corner in Buccleuch Street and still fulfils its original purpose: a thriving community church. Its congregation are very proactive, and it is this that has helped it to continue and avoid the sad fate of two of the four 'apostle' churches built in 1878.

29. Alfred Barrow Higher Grade School

Grammar school education first began in 1879 when the first 'Higher Grade School' was opened in Abbey Road. This was later moved to the present site on Duke Street, close by Schneider Square. The school was finally superseded by the Grammar Schools built at Parkview in the 1930s, although, ironically, it has clung to its existence and outlived both – the Grammar Schools being recently demolished. The school was named after Alderman Alfred Barrow, mayor for six years including during the First World War. It was added to and extended in 1930 to accommodate girls, but eventually the boys' school was removed to a new building at Holker Street (again long demolished). It continued as a girls' school, serving the town's children and changed once more into a mixed-gender comprehensive school in the 1970s. Its reputation and academic attainment

Alfred Barrow School.

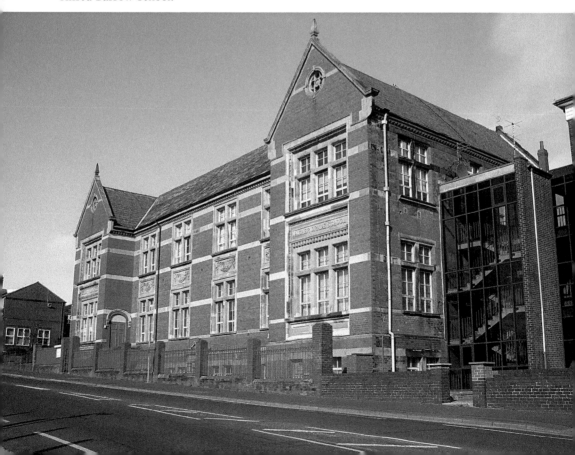

New surgery under construction incorporating Alfred Barrow School.

dwindled over its last years and, after adverse reports, it was closed and the children were absorbed into the new Furness Academy, which replaced all the secondary schools apart from St Bernard's and Chetwynde. It is now undergoing yet another metamorphosis, this time as a GP surgery and centre for the NHS. This will be the most radical change yet, not only in use, but because the building has been returned to its original form – all appendages have been removed and the central building retained as a Grade II-listed one. The new super surgery will be constructed around this building and will provide a new lease of life for a very significant heritage building.

3c. Ashburner House, Dowdales School, Dalton

Dowdales School is a large, popular and successful comprehensive school, accommodating children from ages eleven to sixteen. It is based around the central building of Ashburner House, which is a former mansion that was converted into a school building in 1928. It stands perched on the hill and surrounded by modern buildings, a reminder of its past. The mansion was built in 1895 by George Ashburner, who owned the Elliscales Estate and from whom it took its name. The ambitious building has a three-storey tower and is built from coursed sandstone with a slate roof. It retains many original features inside, including beautiful stained-glass windows, decorative tiled floors, cornices and carving, despite having been used as a school for many years. The Grade II building is a gem and it has survived well. Sadly, George Ashburner did

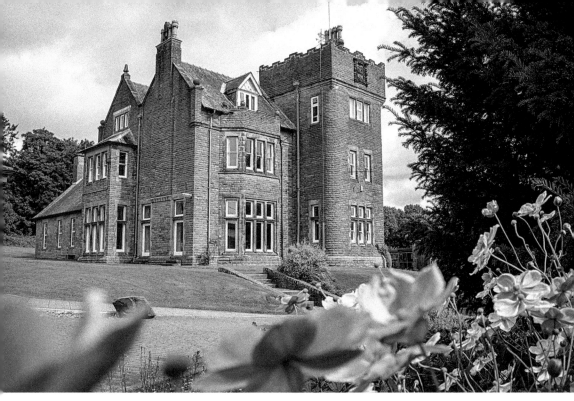

Above: Ashburner House in the summer, Dowdales. (Courtesy of S. Armstrong and Dowdales School)

Below: Ashburner House in the winter, Dowdales. (Courtesy of S. Armstrong and Dowdales School)

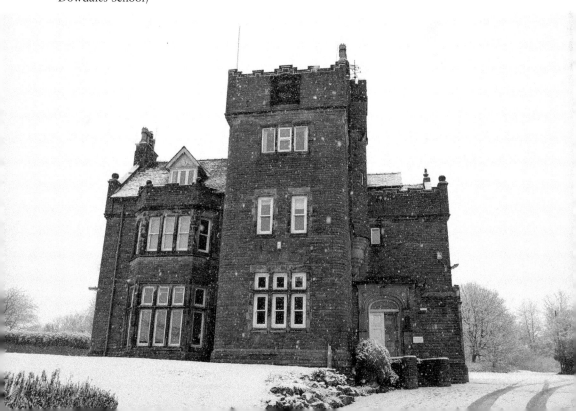

not fare as well as his mansion. Due to inherited financial pressures and debts he committed suicide in 1897 and did not live in or enjoy his house. The house was sold to Mr Kellett a manager of the Barrow Haematite Steel Company. Later, in 1928, it became a school, providing education for generations of children from Dalton and the surrounding villages such as Lindal, Askam and Ireleth.

31. The Technical School (Nan Tait Centre)

Many of us grew up knowing this building as the old 'Tech', which indeed was its original purpose. It is a dramatic and beautiful building, which luckily survived the demolition squad that removed so many old buildings in the town. It stood derelict for many years but was saved by a complete reinvention of its purpose. The Barrow Technical School was opened in 1903 at a cost of £25,000, the foundation stone having been laid by Mrs Albert Vickers in 1900. It was designed by Woodhouse & Willoughby. The red-brick and terracotta building is grandiose and a temple to the arts and education; two panels of Grecian ladies proclaim mottos, '*Ars Longa Vita Brevis*' and '*Labor omnia vincit*'. The town fathers obviously had a serious ethos and

Nan Tait Centre.

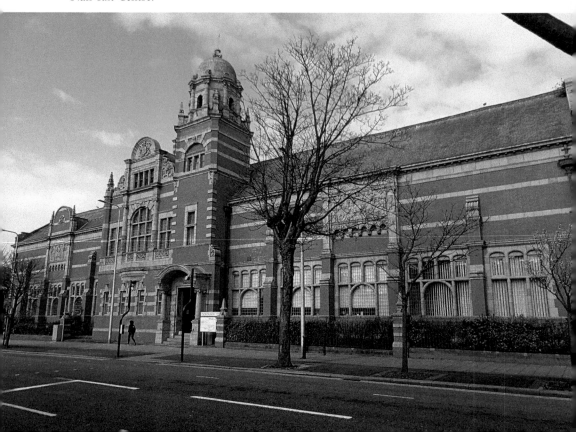

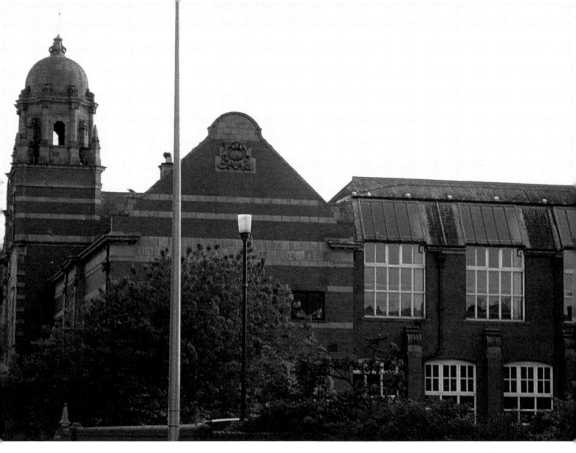

Nan Tait Centre studios.

message for the young – 'work conquers all' – which sits with the work in the local industrial scene very well. However, 'art is long, life is short' seems a little depressing, emphasising the mark they will make through what they produce is more long-lasting and important than themselves. The school was a training ground for the workforce of the shipyard, providing technical education for the skilled trades that were required. It had a great reputation and was used for adult education too. The art school spilled into the defunct Ramsden Baths. It became unfit for purpose by the late 1950s and a new technical college at Thorncliffe was built in 1970, and Howard Street College on Duke Street. These too have succumbed to change: Thorncliffe meeting its demise in 2009 when the Furness Academy opened and Howard Street being abandoned in favour of Furness College. Cumbria County Council saved the building through grants and because it was recognised as an important Grade II-listed building in 2000. The building was named after another local mayor from the 1960s and became an arts centre, council offices and civic offices, and it has been conserved well. The original features are still present, and the staircase and tiling are particularly attractive. The Nan Tait Centre is a testament to the industry and creativity of the town and its people and marks a considerable time in its history.

32. Vickerstown, Walney Island

Vickerstown is a good example of housing built for a particular workforce. Although not quite as comprehensive as Port Sunlight, it was still an innovation in housing. Walney was a rural and farming community, but its proximity to the shipyard made it a suitable location for housing for the employees. Vickers acquired the Isle of Walney Estates Company in 1899 and purchased 341 acres of land on the island. By 1904 they had constructed 930 houses and had laid aside further land for parks, institutes, churches and sports areas. It was a well-thought-out plan and even included the building of the King Alfred Hotel at a further cost of £6,000. The new town was termed 'a marine garden city' and all that was lacking was appropriate route across Walney Channel. The ferry had been improved by replacing the traditional one with a steam ferry and the council permitted a further ten rowing boats to take passengers across. Eventually, it was necessary to build a more permanent link, and this came in the form of the bridge that was opened in 1908. The Vickerstown area is still popular and provides a range of styles and sizes of homes, originally showing a distinction between the

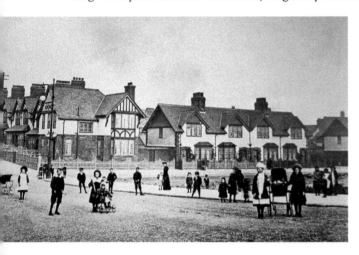

Vickerstown in the early 1900s.

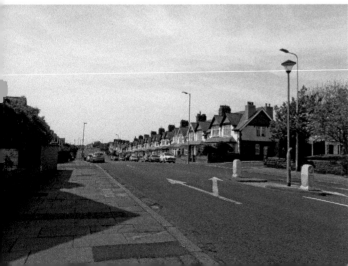

Ocean Road

ranks of workers who lived in them. They are distinctive in their mock-Tudor appearance and the wide streets and gardens provide a pleasant outlook. The population has since grown and even more houses have been built on the island, creating a distinct community that, although within Barrow, is quite unique.

33. The Majestic Hotel, Schneider Square

Like its name, this hotel exudes its importance and significance. It was built at the vast cost of £31,000 in 1904 and was opened in the following year. It occupies a prominent position, on one of the town's main squares and close to the commercial centre. It was regarded as one of the most important public houses by the brewers Cases's and its style is grand and imposing. It was designed by J. Y. McIntosh using a blend of different architectural styles and periods. The Flemish gables lend it a certain presence and it revives the Jacobean style alongside the more obvious Edwardian style. It shouldn't work, but it does, and it is now a recognisable landmark. It flagged in the latter part of the twentieth century and became shabby and unloved. It even spent some time as a refuge for homeless families who were given bed and breakfast accommodation. Its fortunes changed with new owners and a renovation project was undertaken, bringing it back to some of its former glory. The ground floor is occupied by a popular Italian restaurant (Francesca's) and it is now once again a hotel, offering three-star accommodation, which is close to BAE Systems and convenient for contractors who are working there.

The Majestic Hotel, Schneider Square.

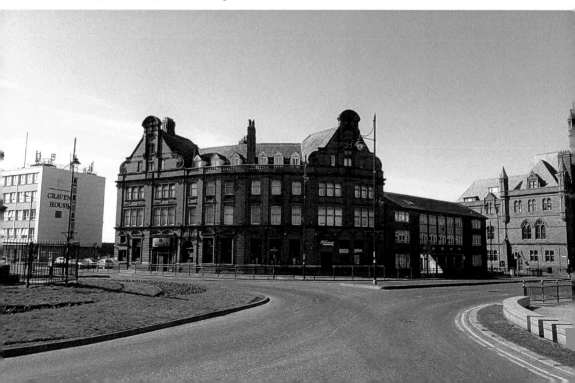

34. Salvation Army Citadel, Abbey Road

In 1881, the Salvation Army emerged in Barrow to provide care and assistance for those in need in the burgeoning town. They originally rented a building but soon moved to Duke Street to a more permanent place. The Salvation Army provided a distinctive style of religion, which practised as well as preached the teachings of the Bible. It used music to communicate, with rousing hymns and songs that appealed to its Victorian congregation and have lasted well into the twenty-first century. The movement grew larger and confirmed its support of the Barrow by committing to a permanent home in Abbey Road. The citadel, which is still in use, was built in 1910, in the same familiar style as other buildings in this stretch of Abbey Road. It has three floors and is a large place suitable to accommodate over 1,000 people. The foundation stone is dated 5 February 1910 and the building occupies a large space opposite the Furness Railway public house. It is a red-brick building with ornate window arches and a sign across the front telling passers-by that it is the Citadel. It has been very active for many years and many Barrovians will recall joining the 'Sally Army' at the Citadel for Christmas carols. Indeed, the Salvation Army can be seen at Christmas on street corners and in various venues

The Salvation Army Citadel.

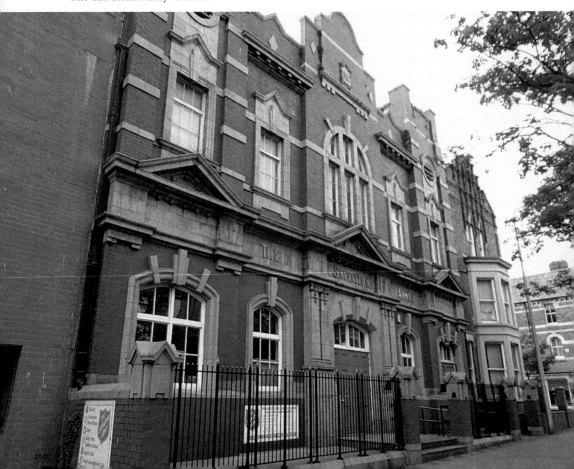

playing their brass instruments and providing rousing renditions of popular carols like 'O Come All Ye Faithful'. The Salvation Army still serves the community, providing social help, advice, religious services and it runs charitable donations of clothes and furniture to sell to assist their work.

35. Custodian's Ticket Office

This tiny oak hut is a heritage artefact in its own right. Built in 1910, it was for the resident custodian of the abbey to issue tickets for visitors to the site. The hut is now a listed building and is under the protection of English Heritage. The building was there to provide a presence on-site and to provide a little added

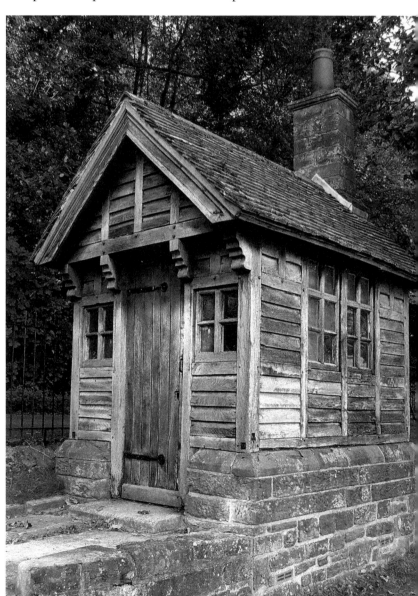

The custodian's ticket booth.

security; its position is certainly better than the current visitor centre, giving a view across the abbey. The booth was large enough for one man and he was lucky enough to have his own fire and chimney. The tickets were issued by him and there was a till, guidebooks and postcards for sale, a far cry from today's vast array of merchandise on sale in the visitor centre. The hut is the only surviving booth of its kind from before the war and it was designed by Frank Baines for the Office of Works. The ticket booth fell out of use when its larger successor replaced it at the top of the site. It still attracts people's attention and is a quaint addition to the medieval monastery it was built to serve. It is oak and brick in construction and has a tiled roof. Its chimney is need of repointing, but its general condition is good. Hopefully it will continue to survive and provide pleasure for future generations to come.

36. Old Fire Station

You might be surprised to realise that a bed shop hides its earlier incarnation as the first designated fire station in Barrow, even if there is a clue in the name. It is an ornate and purpose-built construction, made to house the

The old fire station, Abbey Road.

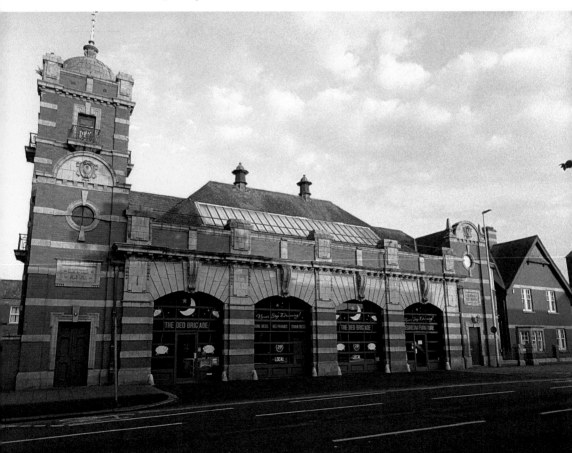

first motorised fire appliances. The four arches at the front were once where the fire engines were housed and garaged. The building dates to 1911 and additionally included a stationmaster's house and accommodation for two drivers. It was in the centre of town and would have been convenient in the early years; however, it was decided that a new building was required. In 1996 one was built that was better placed to serve the community: on the edge of the A590, giving quicker access to outlying areas as well as the town itself. The town had a very rudimentary fire service initially, manned by volunteers and the church wardens of St George's. This would have been adequate to begin with considering the size of the town, but it was soon necessary to formalise arrangements. After the incorporation of the town in 1867 an official fire brigade was created, and firemen appointed and provided with equipment. The building on Abbey Road was the start of the professionalisation of the service and although it is split into commercial units and office space, it is still known as the old fire station, and, of course, is added to the ranks of Grade II-listed buildings.

37. Abbey House

This well-known and popular venue for weddings has reinvented itself several times. It was built by Sir Edwin Lutyens in the neo-Elizabethan style in a 'H' plan. Seated in 14 acres of woodland, its architectural features have chiefly survived, and the solid sandstone construction gives it an air of heritage and age that belies its 1914 creation. Abbey House Hotel, as it is known now, started out life as a prestige hospitality venue for Vicker's Ltd to welcome visiting dignitaries and clients. There was an apartment for the managing director, Sir James McKechnie, as well. The building was sold to the county council in 1951, who transformed it into a home for senior citizens. This endured until the 1980s when the asset was sold in 1984. The building had become worn and dilapidated, having been neglected over many years of use. The new owners restored it and later it was extended to achieve more space for events and weddings. The new wing is partially hidden because of its location to the side of the original, which means that the view from the drive is of the old building and garden – more aesthetically pleasing. One enters the building through a grand sandstone portal, with a date stone and coat of arms above. The new wing, although faced in matching sandstone, is more brutal and less ornate externally. It is pleasant enough but sits a little incongruously with Lutyen's original in my opinion. However, internally the character of the building has been maintained and is attractive and well-thought out. The Great Hall is authentically panelled, and it is here and in the restaurant and bar where one can capture the feel of the original design.

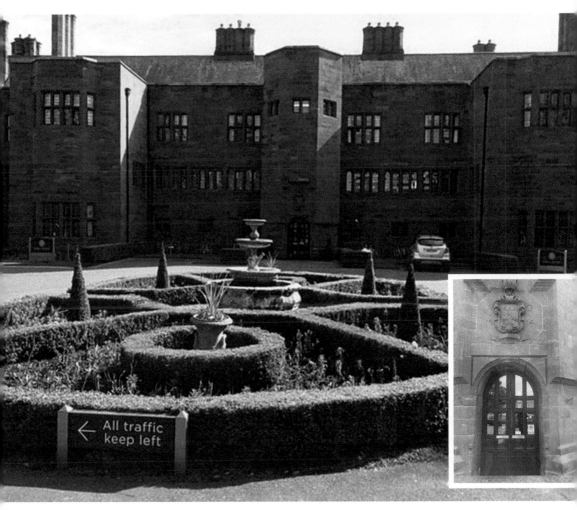

Abbey House Hotel.

Inset: The entrance to Abbey House.

38. John Whinnerah Institute

This beautiful Grade-II, art deco building is not what it seems: it is no longer a functional building and is just a preserved frontage. Behind it a new commercial unit sits in its footprint but is disguised by the original building. It was a compromise that enabled a new build to go ahead, but to conserve the outer shell of the institute. The interior was demolished and the modern retail units were built within it – they have their frontage behind the building and facing onto a small retail park. The original building was constructed between 1937 and 1938 and is a splendid example of the art deco style popular at

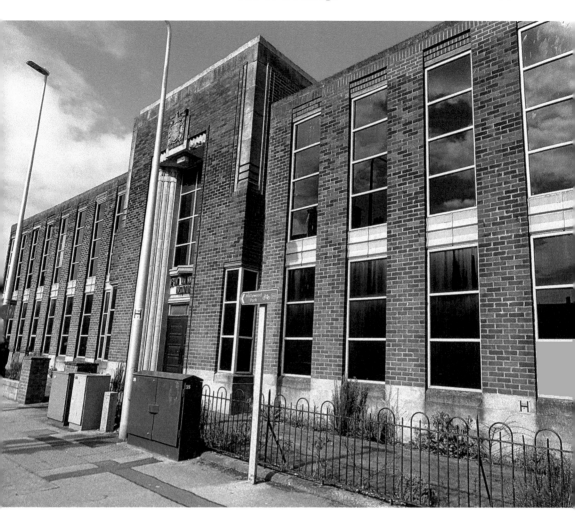

John Whinnerah Institute.

this time. It replaced the Jute Works, which had occupied the site from the corner of Hindpool Road to the corner of Ramsden Square. The building was constructed initially to provide premises for the Women's Institute and the Junior Instruction Centre to improve educational facilities for women and young people in the town and make them accessible to everyone. The idea was to encourage women and girls to aspire to wider skills such as commercial jobs as an alternative to factory work. The Women's Institute was praised by the chairman of the National Union of Teachers as being one of the most effective in the country. The building was used for education services in the town and continued even after Cumbria County Council took over services in 1974 following the administrative boundary changes. The building is named after John Whinnerah, who was a mayor of Barrow-in-Furness in 1928–30. He was

also the chairman of the council's education committee, so an appropriate person to name the institute after.

39. St John's Church, Barrow Island

This is an unusual Grade II-listed building with some interesting features. The current building replaced an earlier one consecrated in 1878. There were four churches built at this time to accommodate a growing population: St John's, St Luke's, St Mark's and St Matthew's, named after the four evangelists. The original building here was temporary, built by Paley & Austin in a timber and brick construction. These four churches have fared differently over time: St Mark's has been refurbished and is still in use, St Luke's was recently demolished and has been replaced by modern sheltered accommodation, and St Matthew's

St John's Church, Barrow Island.

St John's Church.

was rebuilt in the 1960s and is now closed, not having been in use for worship since 2015.

St John's is made from ferroconcrete, concrete and a green slate roof in the Byzantine style, with a curved apse. It has an enlarged crossing and has some of the original fittings from the earlier church. These include the eagle lectern, wooden pulpit and carved choir stalls made by F. J. Lord in 1922. The new church was built in 1934 by Paget & Sealey of London and consecrated in 1935. The west window houses some of the nineteenth-century stained glass depicting St John, St Mary and Dorcas. Its style is typical of the 1930s and makes it a unique church in the area.

40. The Police Station and Magistrates' Court, Market Street

The police headquarters and court were established in 1958, housed within a typically 1950s design. The building takes up the corner of Market Street and is opposite the town hall, giving it prominence. The court is attached, and a pillared

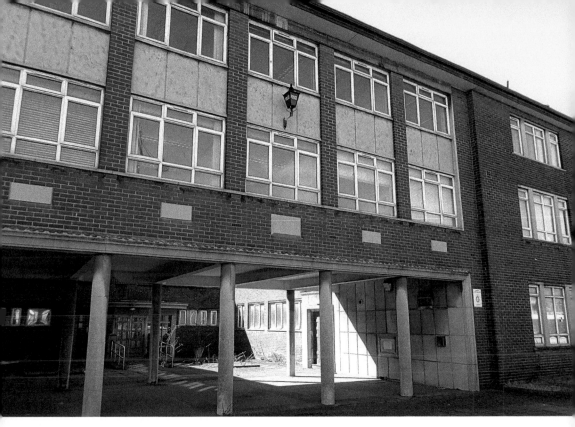

Above: Magistrates' Court.

Below: The new Magistrates' Court, Abbey Road.

The old police station, Market Street.

courtyard fronts the entrance to this. Access to the police station is at the side, slightly set back with geometric, concrete flower containers along the raised beds. The station had cells and offices, all commensurate with the needs of a growing police force. Apparently, a time capsule was buried beneath the foundation stone, so one wonders what will happen to it when this building is demolished. It also suggests that the anticipation was that the building would survive many years into the future. The designers and builders would no doubt be aghast that in just under sixty years the building would be judged obsolete. The complex is to be replaced by a mid-town hotel in a less impressive building, which will do little to complement the old town hall. Planning has been given to build a Holiday Inn Express, but this is subject to archaeological survey to be undertaken prior to the work. The project is not without its critics, with many feeling that it is an austere and unsympathetic design that will replace the court and police station. This could reveal some of the earlier history of the town hidden beneath the 1950s building. Although it is sad that the building will disappear, it gives an opportunity to find out more about the original village of Barrow, which is an exciting prospect. The police are now housed in a central building at St Andrew's Way, which suits the needs of a modern service.

41. College House, Howard Street

A rapidly growing need for expansion in education demanded the creation of new premises for technical training and education. The demand for adult education, further education and apprenticeship schemes was met by the building of the Central College of Further Education at Howard Street. This was opened in 1964 and was the first phase of the reorganisation. The second phase was carried out by providing a new modern technical school on Thorncliffe Road. Howard Street was later abandoned as a college of further education and new premises were built at Channelside. These buildings were recently refurbished creating the modern building housing Furness College. College House has now become a day nursery and services offices for a variety of education and assessment facilities. The college is fronted by a green and one of the town's heroes is commemorated there. An evocative statue captures the speed and skill of rugby league player Willie Horne and is appropriately positioned opposite Craven Park rugby stadium. Horne played for Barrow, Lancashire, England and Great Britain and captained all four sides in the 1940s–50s; he was inducted into the Rugby League Hall of Fame in 2014.

College House and the Willie Horne statue, Howard Street.

42. Barrow Sixth Form College, Rating Lane

Before the sixth form college was established in 1979, sixth form education was provided at the local Grammar Schools and Chetwynde Independent School. The two Grammar Schools merged to form a comprehensive school for eleven to sixteen year olds and the college was to provide A-level education for sixteen to eighteen year olds. The building is a distinctive brick-built college with playing fields and facilities for the students, including ICT, a refreshment area and a performance area. It has facilities for disabled students and acts as a satellite campus of Beaumont College at Lancaster. It is set back from the road and occupies a place on the rural edge of Barrow, very close to the medieval remains of Furness Abbey. The college has recently gained chartered status becoming a member of the Chartered Institution for Further Education and it has amalgamated with Furness College. The sixth form college will retain its academic identity and will complement the vocational and technical offer of Furness College. The amalgamation opens connections with UCLan and the University of Cumbria and it has some notable previous students including Steve Dixon, a news

Barrow Sixth Form College.

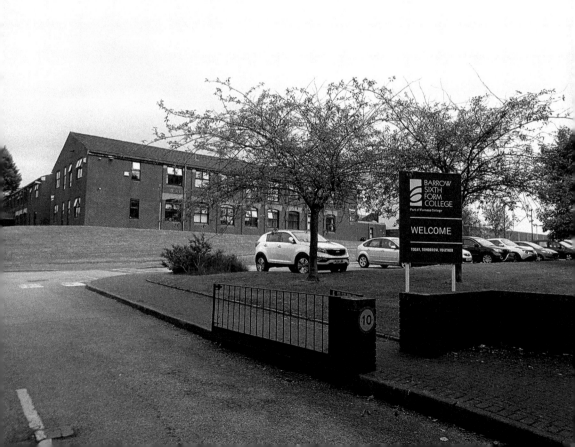

anchor for Sky TV; Liam Livingstone, Lancashire cricketer; and Cat Smith MP. It had operated innovative schemes that link it to various universities and it has annually proved its worth in its academic success.

43. Furness Abbey Visitor Centre

In 1982 English Heritage built this unique, if slightly incongruous, modern building to house the abbey artefacts and provide a shop. It is brick-built with an angled roof, giving it a distinctive appearance. It has softened over the years with ivy and climbers covering its harsher aspect. As a functional building it is perfect and gives adequate space to show of the grave covers and effigies housed within it. The wood-panelled ceiling reaches quite a height and its structure is solid, providing an exhibition area, shop and education room. There are interesting panels telling the story of the abbey at one end and a stone room close to where the abbot's crozier (found 2010) is housed in a special cabinet for visitors to see. The museum houses a permanent exhibition about the abbey and has access for those with mobility issues. Outside there is a car park for visitors and which is

Furness Abbey Visitor Centre.

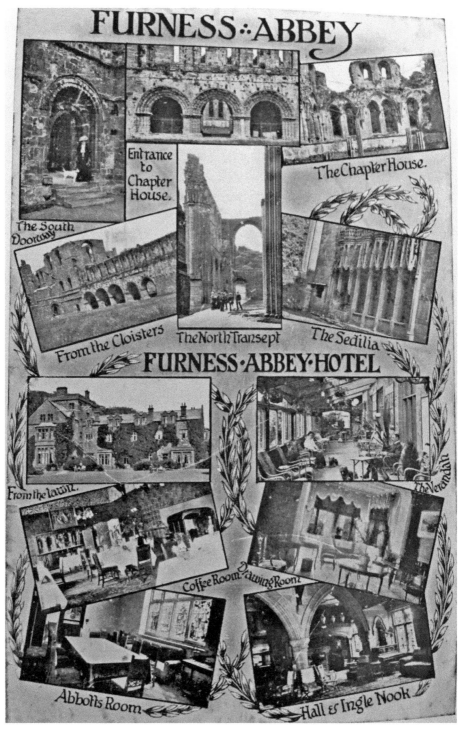

Postcard of Furness Abbey Hotel.

roughly located on the site of the Manor House built by the Preston family post-dissolution. Much later this was demolished to make way for a hotel, which was part of the tourist offer for the Furness Railway. The postcard shown entices the visitor with images of heritage, history and comfort. The pictures of the rooms within the hotel makes one wish it had survived; it would not be out of place as a holiday destination and these days would probably have a spa attached and be classed as a 'boutique' hotel. The Abbey Tavern is the remnant of the second-class buffet and ticket office for the station, which was to the north of the visitor centre. It is in a dilapidated state at present but has been rescued by English Heritage and will be restored to its former glory, probably in a completely new incarnation.

44. Devonshire Dock Hall, BAE Systems

This enormous building dominates the skyline of Barrow and can be seen from almost any location around the town. It was built above the Victorian Devonshire Dock and straddles most of it with its huge construction shed. It is

Devonshire Dock Hall.

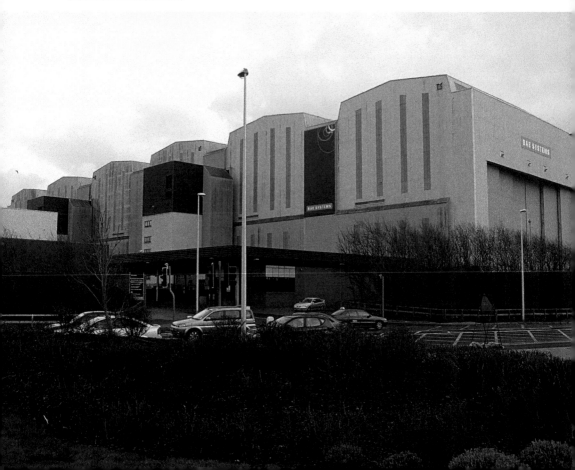

Central Yard Facility.

an indoor submarine complex that was built by Alfred McAlpine PLC between 1982 and 1986 to house the Vanguard and Astute class of submarines. The building had a dual purpose: both for protection of the vessels from adverse weather and for security purposes, to prevent spying from satellites. The upgrading of the naval submarine fleet from *Polaris* to *Trident* by the Thatcher government was the reason for this construction and it changed the aspect of the Devonshire Dock forever. More recently another large building has been constructed, which is 15 metres high. The Resolution Building, named after the Royal Navy's first submarine to carry nuclear missiles and launched in Barrow fifty years ago, is completed. The huge 28,000-square-foot warehouse will store highly classified and sensitive components and materials that will be used in the construction of the Successor class of submarines. This is one phase of the project and we can expect the skyline changing even more over the coming years. An even bigger prospect is the 'Son of DDH', or to give it its correct title, 'Central Yard Facility'. It is an enormous box of a building within the shipyard complex, dominating the view across Walney Channel and visible for miles around. The government contract will apparently provide jobs for the next ten years and is yet another lifeline for the town arising from its long association with shipbuilding and armaments.

45. The Dock Museum

An innovative scheme to transform a defunct Victorian graving dock was suggested and in 1994 the town museum was removed to the new building above the old dock. The graving dock was built in 1872 and allowed ships to be fitted out and repaired via a channel and sluice gates into Walney Channel. It was a cold, dank and inhospitable workplace, with tiered sandstone steps for the workers to access the hull of the ship – often treacherous and slippery in wet weather. The dock fell out of use and the local council decided that it would be an appropriate site for the new museum. It has a fascinating history of the town and its industrial rise, as well as galleries dedicated to shipbuilding, early history and social history. There has been a museum in Barrow since 1907 (previously housed in the Main Library) and the access to it is free. It attracts thousands of visitors each year and is a popular destination for visitors to the Lake District. It recently had the opportunity to purchase a Viking hoard and a Roman bracelet – both found locally as treasure trove. The items were saved by public subscription and donations and are on display in the museum. BAE Systems hire part of the building as offices, but it is still possible to see the graving dock from the gallery above.

The Dock Museum.

46. Emlyn Hughes House, Abbey Road

Barrow Borough Council was responsible for commissioning Emlyn Hughes
House, completed in 2006. It is a 'Marmite' sort of building: you either love
it or hate it. Part of the resistance to the building lies with the destruction of
the beautiful if dilapidated art deco cinema that it replaced. The building was
in disrepair and would have been expensive and difficult to renovate and was
demolished. It is still cited as one of the buildings that should have been 'saved' by
the council (despite it not being owned by them). The office building replacing it
is a confident modern building designed by Bowker Saddler. It is a clever design,
mimicking the main industry in the town, with its maritime curves and ship's prow
appearance. This does not convince some people and the local myth emanating
from it suggests it is a white elephant and is virtually empty. I am assured by those
who know that this is not the case that it is fully occupied. It derives its name from
England and Liverpool footballer Emlyn Hughes, who was born and raised in the
town. His statue adorns the front of the building and it is flanked by Holker Street
and on the other side Coronation Gardens and from that direction the view is very
pleasant and attractive, despite the detractors.

Emlyn Hughes House.

Emlyn Hughes House and statue.

47. Furness College, Channelside

Furness College is now the largest college of further education in Cumbria and is a member of the Chartered Institute for Further Education. The college is now able to offer degree education and is affiliated with University of Central Lancashire and Lancaster University. It had a complete refurbishment and development costing £42 million and this was opened in 2012. The modern building has a very industrial feel to it, which supposedly reflects the industrial training that is part of its remit. The main building is clad in an unattractive brown outer membrane and is an unusual shape with a white frontage. It resembles a factory or industrial storage unit more than a place of learning, but is aspiring to be modern and state of the art. However, inside it is very different, with an attractive entrance hall, glass panels and open spaces. Teaching rooms can be reached via lifts and there is another building housing the Advanced Manufacturing and Technology Centre, which recently won a prize for design in the BBC North West Tonight People's Choice award for 'North West Building of the Decade'. It is large enough to hold nearly 4,000 students, apprentices

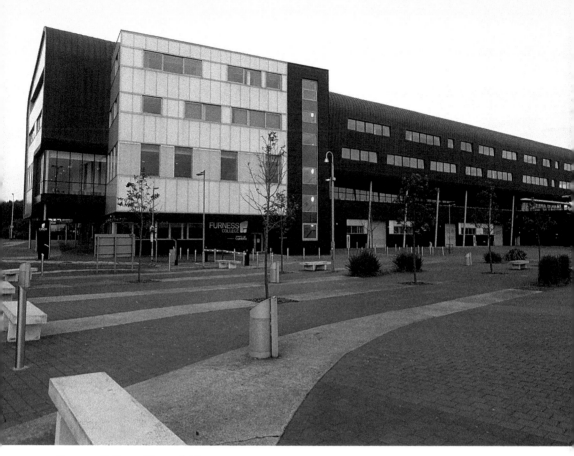

Furness College, Channelside.

and staff and has all the necessary facilities required of a modern college. It has merged with Barrow Sixth Form in 2016 and this expands the educational offer to include A levels.

48. Furness Academy, Parkside

In 2013 a new building was opened to house the pupils from the buildings at Parkview and Thorncliffe. This was the ultimate step to create a single academy for the town and was the final one to be established in Cumbria. The old Parkview and Thorncliffe sites were demolished and the land sold for yet more housing. The new academy retained some of the old playing fields but has had a professional running track added. It is sponsored by BAE Systems and cost £22million to build. There has been controversy around the inception of the academy: firstly because of the resistance of local parents to the amalgamation of three schools, one of which was in 'special measures'; secondly, the furore over the proposed demolition of the two 1930s Grammar Schools, which had been the Parkview site, despite

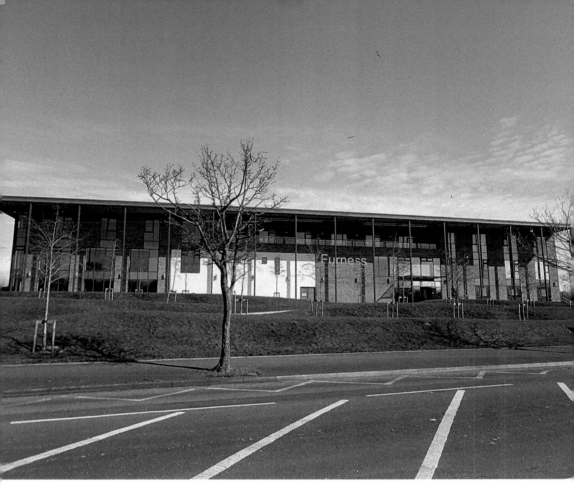

Furness Academy, Park Drive.

their affection in the hearts of many local people and ex-pupils; and thirdly, over the exclusion rates at the new academy. To top it all, there was a dispute between the school and Ofsted with regard to its 'inadequate' grading of the educational provision, financial management, redundancies and three headteachers who left in quick succession. Hopefully, the teething troubles are now over and the academy can grow in strength and provide the best education the town's children deserve.

49. The Police Station, St Andrew's Way, Barrow

This 8.6 million eco-friendly building is the last in a succession of police stations serving the community of Barrow. The building is a big departure from the previous buildings, being open-plan and housing 300 staff. It has an eighteen-cell custody suite providing spacious facilities and room to process offenders and facilitate interviews of witnesses and victims. It has all the modern facilities such as CCTV and it is compliant with the requirements of the Home Office. Its predecessor in Rawlinson Street was humbler. In 1874 a lease was taken out on two houses, one

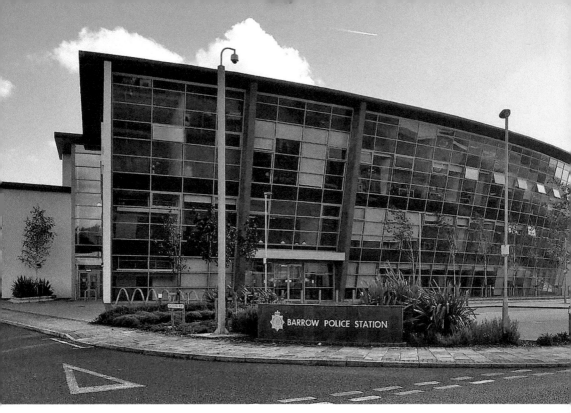

Above: Barrow Police Station.

Below: Police station, Rawlinson Street.

in Rawlinson Street and another in Crellin Street. The police station at Rawlinson Street is easily identified because the tiling on the wall reads 'Police Station 1880'. It is in the centre of a terrace of Grade II-listed houses and is constructed from red brick with Flemish bond. Its position was in one of the main streets in Barrow and would have been centrally placed for speedy intervention. Barrow was part of the Division of Lancaster Police prior to 1881 and the town had had difficulties with keeping order during the disturbances in 1864. An influx of Irish labourers had caused a reduction in wages, which had caused civil unrest. Groups of vigilantes were active in rounding up the Irish and removing them for the town. The small police force was unable to control the situation and it was realised that more constables needed appointing. The town gained its autonomous Police Force in August 1881 with Captain RNC Foll as the chief constable, and from this it grew, eventually being absorbed into Cumbria Police.

50. South Lakes Birth Centre

One of the newest buildings in Barrow, the South Lakes Birth Centre, has risen from the ashes of tragedy. Built in response to the baby deaths at Furness General Hospital, following the Kirkup Report in 2015, this £12 million centre is state of

South Lakes Birth Centre.

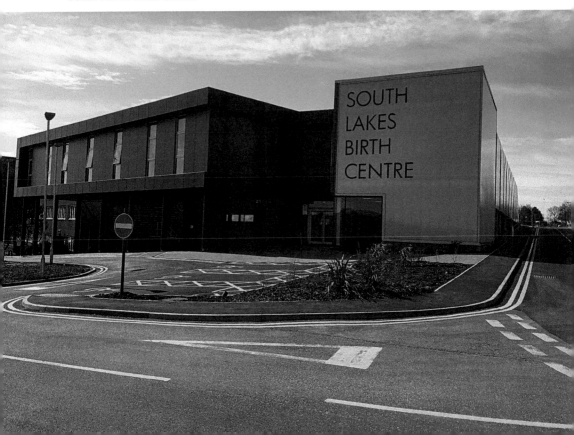

the art and includes a bereavement suite and garden, special-care unit, birthing rooms, facilities for partners and operating theatres. It is built within the Furness General Hospital site and is an imposing new building in a functional modern style. It was opened on Valentine's Day – 14 February – 2018 and has taken five long years to come to fruition. It is hoped that the modern facilities will help to increase the recruitment of midwives to the unit. Previously the maternity care was provided within Furness General Hospital. The new building is a dedicated unit in much the same way that its earliest predecessor, Risedale Maternity Home was. Risedale was positioned on Abbey Road and was a dedicated maternity hospital. It also had an annexe for those with complications and had an excellent reputation. It was founded in 1921 and closed in 1984 when Furness General Hospital opened. The hospital is now a residential care home and the annexe has become a day-care nursery.

Acknowledgements

The author would like to thank the following people and organisations for their assistance in researching this book. Many thanks to Barrow Library and Barrow Local Studies and Archives for information acquired from their resources over recent years. Thanks to Keith Johnson of Barrow Borough Council for his information and insight into some of the changes and developments in the buildings of the town. Thanks to S. Armstrong and Dowdales School for use of their photographs.

Acknowledgements for the use of copyright material: English Heritage, National Trust, Historic England and Greenlane Archaeology, when researching buildings. Every attempt has been made to seek permission for copyright material used in this book. However, if such material has been used inadvertently without permission or acknowledgement I apologise and will make the necessary correction at the first opportunity.

The following publications were used during research:
Barnes, F., *Barrow and District*
Beck, T., *Annales Furnessienses*
Jopling, M., *Furness and Cartmel*
Leach, A., *Collective Works*
Thurley, S., *The Men from the Ministry*
Trescatheric, B., *Collective Works*
Walton, J., *A History of Dalton-in-Furness*
West, T., *Antiquities of Furness*